# *Watercolor Painting on the Trail*

# *Watercolor Painting on the Trail*

## A Hiking Artist's Handbook

### Judith Campbell

APPALACHIAN MOUNTAIN CLUB BOOKS
BOSTON, MA

*Library of Congress Cataloging-in-Publication Data*

Campbell, Judith, 1948
    Watercolor painting on the trail: a hiking artist's handbook / Judith Campbell.
      p. cm.
    Includes bibliographical references and index.
    ISBN 1-878239-29-5: $18.95
    1. Landscape painting—Technique. 2. Watercolor painting—Technique.
I. Title
ND2240.C35   1993
751.42'2436—dc20                                     93–11461
                                                                     CIP

# Contents

**Section III. Getting Creative—The Next Steps**

# Preface

Ideas for this book have been cavorting through my consciousness for several years. It more or less crystallized when I was kidnapped at brush point by a class of painters I was teaching at the AMC Pinkham Notch Visitor Center and was forced on a one-and-one-half mile hike into mountain forest to Lost Pond. I was not a hard-core hiker, but these hardy souls convinced me I would love it. They bribed me with the idea that we could combine some hiking with some art making and learn about painting outside, "on location." Once out, we all discovered that neither I nor they could paint because we were poorly equipped, both for seeing and painting. The heat, bogs, mushy ground, slippery rocks, and cumbersome studio equipment proved to be a real hindrance. The walk, though, was truly beautiful, and the experience was invaluable to the planning for this book.

Our land is beautiful and I paint it again and again. I have learned to cope with the elements in a variety of ways. I've painted more than one prize winner in a tent, for example, dotted it with bug spray, and dipped my brush into a coffee cup almost as often as I've dunked it into water.

My goal in this book is to address the spirit of painting as well as the act of painting. Since writing my first book, I have become keenly aware of this aspect in my teaching and in my own art making.

Learning to paint can seem as frustrating as trying to put up a tent in a windstorm with one hand tied behind your back. It can also be the most relaxing and enlightening activity you have ever encountered. For me, it is both, and often in the same painting. It's soothing when I remember that it's not a product I am producing but a process I am experiencing. With that as my focus, I am open to adventure and learning, and I am never in danger of failing.

This book, therefore, has been a process of self-discovery as well as a literary project. As it has unfolded, I have become delightfully aware of my own joy in the painting, teaching, and learning processes. This pleasure, plus a few well-chosen techniques, is what I want to share with you.

I want to thank my endlessly patient typist/editor and reassuring friend, Pat Lobaton, for her steadfastness in the face of my occasional lunacy and for making perfect sense and order out of a sea of papers that often threatened to overwhelm me.

I also want to thank the other Pat, Pat Isaac, who took many of the photos in the book and developed almost all

of them. Pat is an art teacher and artist in her own right and has been a terrific right hand in all of this.

The biggest thank you goes to Gordon Hardy, my editor and editor of AMC Books, who helped me envision this book and make it a reality.

Finally, to my family—my two sons and their wives and my husband Chris, whom I met at Pinkham that same summer—and to my beloved students, I dedicate this book. You all have nurtured and vitalized me as artist, teacher, and citizen of this planet Earth. And as I paint her landscapes, whether on the trail or from an AMC classroom window, I am unerringly reminded that I am my mother's keeper—and so are you.

# Introduction

Why are you looking at this book? There are many possible reasons. You are a hobby painter or artist looking for new ideas. You are an outdoors person looking for yet another way to enjoy the world of nature and have always wanted to try your hand at painting. Perhaps it is a gift from a well-meaning friend or relative who thinks you need a hobby. At one time or another I have acquired a new book for all of those reasons and more.

Because we humans communicate in words and in images described or presented, the illustrated book provides the reader with one of the best opportunities to learn and to understand what another human being is trying to say. I know that when you read these pages, with or without the hands-on practice, you will never again see the natural world in your old and stereotypical way.

You will never see a mountain, a sunrise, or a shaft of light piercing a morning forest mist in the same way, once you have tried to describe it with a pencil or a brush.

Monet, in his series of paintings of grain stacks and cathedrals, showed us what sunlight and season of the year could do to the appearance of a grain stack and the facade of a cathedral. You can look at these paintings and marvel at the brilliant nuances of color, but it is only when you try to show the grace of a sun-sprinkled, leaf-strewn "road less traveled" with your own hand, that you see it for perhaps the first time.

You who are active outdoors people, you who have hiked into Tuckerman Ravine or climbed a rock face in the Sierra Madre mountains or camped alone in winter's blue-cold frozen mystery, already respect and revere the natural world.

In this book I try to give you another way of seeing and feeling the natural world. It is probably less taxing physically than an Outward Bound adventure or a high-ropes course, but the mental challenge will more than compensate.

After reading this book, the physical challenges of hiking, camping, and climbing will be just as exciting. The smell of wet pine needles after a rain will still return you in a flash to your first camping trip. I hope, though, that you'll see and feel so much more.

At the end of a painting workshop with me, my students are often physically exhausted as well as mentally fatigued, and many don't have any idea why. All they know is that something is happening to change the way they view their world. And whatever it is, its fullness is keeping them awake

long into the night with new visions and ideas around a subject they thought was as familiar to them as breakfast.

Loosely defined, art is visual communication. The purpose of this book is to help you learn to really see what you are looking at, then to record what you want of what you see, and, finally, to take those experiences into the realm of creative or personal expression. I do not favor a literal or highly realistic or representational style of painting over a more personal and interpretive abstract style. You must choose a style of expression that suits you.

After experimenting and working for some years in oil paint, I turned to watercolor as my primary medium of expression. This happened because I was looking for a medium that suited my spontaneous nature and my love of the outdoors while accommodating my need to travel and paint in an unencumbered way. Watercolors dry as fast as atmospheric conditions permit. A compact but complete painting setup can fit in a cosmetic bag or, as in my case, a plastic microwave container. And the spontaneous nature of the medium itself is a constant delight, whether on the trail or in the studio. I settled on watercolor about fifteen years ago, and I am still delighted and surprised with its creative possibilities each time I sit down to paint.

Throughout the pages and chapters of this book you will look at the world of nature: trees, land masses, rocks, growing things, atmospheric effects and conditions, moving and still water...and more as you encounter it. In very practical ways I will show you how to see it, feel it, draw it, and finally paint it. Later on you will combine individual subjects into compositions, learning how to choose selectively what will best fit into the painting and, just as important, what to leave out.

Finally, I will make some suggestions about creative or more personal expression and approaches using my own experience as an artist and the experiences of other artists from both the representational and expressionist traditions whose work I respect.

I invite you to share this part of my journey. Use what you can for now, and return to it later and glean a little more. It is much like a favorite place you like to revisit. The familiarity is comforting, but there is always some new little thing to be discovered if you take the time to really look and to really see. Painting for me is as familiar as the old shoe and as new as the sunrise. I will say now, and again many times throughout this book, that painting is a skill that can be learned. You don't have to be a born artist. A visual artist is a person who has learned to paint, and then, to those varied but finite skills, has made the decision, consciously or unconsciously, to add large measures of intuition and "artistic license" to the process.

I think it is proper to tell you a little of my own journey. I did not start in the traditional manner. I did not go to a proper art school or start painting seriously until I was twenty-eight years of age, and professionally until I was twenty-eight and a half. I went very quickly from the kitchen table to the walls of an exhibition gallery, but more importantly, in those first few months of serious painting, I made a commitment to myself to follow this path to its conclusion. Here is how it started.

In February 1968 I was housebound with my two darling toddlers

because of three successive New England snowstorms, and my brain was rapidly turning into the nameless mush I was feeding them.

On one of the evenings of my discontent, I located an old piece of #2 grade plywood, 3' x 4', complete with a strategically placed knothole; a large box of oil paints; brushes and palette knives that I had acquired somewhere along the way; and a rickety old easel a friend had given me. This was my foundation for becoming an artist.

With no real idea where to begin, I smeared white oil paint, like cake frosting, all over that piece of plywood with a palette knife. To that surface I began to mix and add touches of a color called Payne's gray, and before long a landscape began to emerge. The knothole became part of one tree, more trees soon materialized, and finally a little stream appeared in the field of white snow in the foreground. Two colors, and a miracle. At least I thought it was. It was my beginning as an artist.

I know that whether I paint two paintings a year or two hundred, I give to each one the freshness of my vision, and the experience of my life up until the moment of the work. It is very freeing, like being a child again. All children are artists until they begin to worry about what other people think. It takes us years to overcome that.

Finally, I'll answer one of the questions most frequently asked of me: How long does the average painting take me to complete? My answer is two to eight hours and fifty years. (Next year my answer will be two to eight hours and fifty-one!) The purpose here is to let you know there is no "norm." Time will delineate those master- and mistresspieces that will endure and speak to future generations of students. Whether your works will hang on museum walls is probably something you will not know, but it should also not be a concern. Love the moment, and in so doing, love and protect this beautiful planet and its trees, its mountains, its deserts, and its waters. As you respond to them with paint and paper and give them new life in your paintings, remember that you can never "capture" a mountain or a river in a painting, you can only liberate your vision of that place and share it with your viewer.

# Section I

# Getting Started—Tools for the Artist

# Chapter 1

# On Location: Setting up, Setting out, Settling down

*What You Need and How to Use It*

*Keep your materials simple and portable.*

**Fig. 1**

My recommendations for successful on-location painting include three basic concepts: the "kiss" principle ("keep it simple, silly") less is more, and practice before you paint.

Nothing is more disconcerting than planning to paint on location, and being poorly equipped and prepared. Any hiker can relate to this. I have chased vagrant paintings into trees and plucked them out of streams because I forgot to anchor them properly before I started. I have sat on wet sponges and dumped my paint water into my lap. But possibly the funniest mishap was when I caught an unexpected sneeze with a tissue I had used to salvage a too-dark sky, and returned from my painting hike with a bright blue nose!

## What to Carry

Keep your materials simple and portable.

There are painters (Monet was one) who do almost all of their painting outside. These painters carry whole studios on their backs, or outfit their cars or vans for painting. I like to paint anywhere at all at a moment's notice, so on-location painting for me should not be a safari. For the hiker, it should be simple to set up and should clean up in the time it takes to think about it, or in the time it takes to retreat from a summer squall.

Here is what I carry: It all fits into a 6" x 9" plastic microwave container that fits easily in a carrying pouch with a shoulder strap, or in my daypack so that my hands are free.

Below is a picture of my Field-Pack Studio™ (fig. 2). You can set one up yourself, or you can order one directly from me (see appendix).

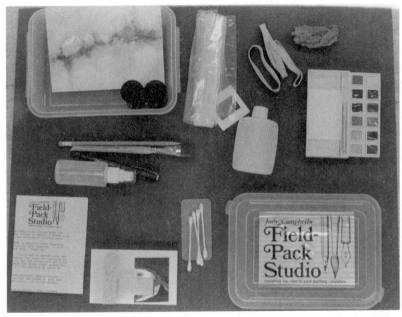

*Field-Pack Studio.*                                    **Fig. 2**

Going counterclockwise from upper left, here is what you see.

Field-Pack Studio kit bottom with 2 water cups (used film canisters)
Pencil
3/4" aquarelle brush
Pen
Spray bottle
Directions
Cellulose sponge
Eraser
Sketch pad

Piece of red acetate (to check color values)
4 Q-tips
Blank credit card
Cover of Field-Pack Studio
Cotman Watercolors Field Kit
Collapsible brush
Natural sponge
3 rubber bands
Plastic bottle for water
Empty slide holder
3 resealable plastic bags

## Paint

To carry my paint I use a travel palette, either a commercial one or a small plastic folding one that I have loaded with tube paint myself. If you use the latter, or if you have to refill the travel palette, give your paint twelve to twenty-four hours to "set up" and dry up, so that it will not "drool" all over your paper (or worse, your clothes). Carrying it in a resealable plastic bag will help prevent this as well.

**Colors.** Carry the basics, that is the primaries! Primary colors are red, yellow, and blue. They are called primary because they cannot be mixed from any other colors and they will make all the colors of the spectrum if they are properly mixed. You will learn a lot more about color in the next chapter, which is specifically devoted to the subject, but here I am telling you what you need to get started at minimum cost and weight in your kit. The colors with an asterisk are the five I carry when painting on the trail.

* alizarin crimson (a deep transparent red)
* Indian yellow (a strong transparent yellow)
* Antwerp blue (a light, transparent cool blue)

  French ultramarine (a warm blue)

  sepia (dark transparent brown)
* warm sepia (my favorite brown, very dark, mixes well)

  sepia umber (good dark brown)

  burnt sienna (a warm, transparent orange-brown)

  yellow ochre (when in doubt use yellow ochre...I'll explain that later)
* olive green (personal favorite, good natural green)

  manganese blue

These are my favorite colors. I can mix almost anything with them; they are (with the exception of the sepias) non-staining colors, which means you can remove them easily; and they are mostly transparent colors, which means you can layer them without their getting muddy.

**The Financial Properties of Paint.** Finally, a word about what kind of paint to buy. That word is *expensive,* the best you can find, the very best. It is better to buy four tubes of the very best paint than the $3.98 special that offers twenty-two colors in a cute little box. Good paint is almost pure pigment with hardly any "filler." Fillers stretch the quantity of paint and dilute the quality. They are more opaque and make your paint look muddy. Good paints are intense in color because they are unadulterated. They go farther and make prettier colors. *They* are the bargains in the long run. Shop around, get catalogs, and ask for student discounts when you go to the art-supply store. Pick up one of the popular home-artist magazines, such as *The Artist's Magazine* or *American Artist* (available at many art-supply stores) and call all the 800 numbers in the back to get free art-supply catalogs. There are some amazing bargains to be found in paper and brushes as well as paint. Always buy the best. I have listed

my favorite places to get supplies in the appendix. My favorite all-purpose paper is d'Arches 140 cold pressed, either in sheets or on a block for traveling. And if you want a real thrill, find some Caran d'Arche watercolor crayons, available in kits or by individual sticks (suppliers in appendix), and try those. If you are going to buy some of these watercolor crayons, start with a small kit, eight to twelve sticks. They are about $.90 to $1.00 a stick, but they are fantastic! They combine the most exciting qualities of color with the intensely personal and calligraphic qualities of line!

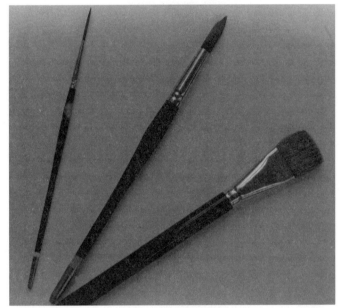

*Brushes (from left): "rigger," #10 round, 1" aquarelle.*

**Fig. 3**

## Brushes

You will want two or three at the most for travel (see fig. 3), and in a pinch you can make do with one. The number on a brush refers to its size. *Round* brushes go from numbers 0 or 00 to #24 and sometimes #36, with the size increasing accordingly. *Flat* brushes are usually labeled or numbered by measurement. A 1/2" flat is just that, and a 2" flat is four times wider. A 3" or 4" brush usually qualifies for house painting and does not belong in a field kit!

The most versatile brush is a good #10 or #12 round if you are going to carry only one. Morilla, Robert Simmons, Grumbacher, and Winsor Newton all make good brushes.

The round brush is a good all-purpose brush because you can use the tip

*#10 round; pressure alone varies the thickness of the strokes.*

**Fig. 4**

*The 1" aquarelle offers a broad range of possibilities.*

**Fig. 5**

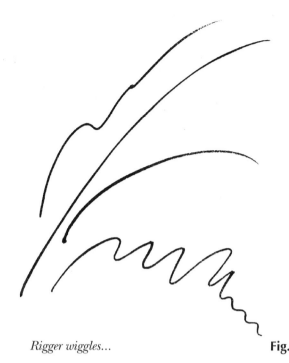

*Rigger wiggles...*                    **Fig. 6**

for detail work, and the side for broader strokes. Vary the pressure for a thick or thin stroke (fig. 4).

If you can carry more than one, include a #7 or #8 round and a 3/4" or 1" flat aquarelle. The aquarelle brush often has an angled, beveled back end that is very handy for scraping highlights or adding texture (more about specific techniques later).

The flat aquarelle gives a square-ended stroke (good for shingles, clapboards, buildings, fences, etc.). But when you twist it, you can get a ribbon-like stroke that has several uses (fig. 5). It's also good for carrying lots of water for background washes such as skies or large bodies of water.

Your third brush should be a long-hair "rigger" #3 or #4, sometimes referred to as a sign brush or a striper.

The rigger or striper is handy for long sinuous strokes (fig. 6), such as grasses, tree branches, boat and ship rigging, and flying hair and animal whiskers!

The cost of a brush does not always determine its value as a tool. I have gotten some excellent brushes for relatively little money. A good rule to follow when purchasing a brush is to test it for "snap." To do this, ask the salesperson for some water, thoroughly wet the brush hairs, and "snap" the water out of the brush with a sharp shake of your wrist. Now push the hairs of the brush over to one side with your finger. When you remove your finger from the brush, a good brush will pop (snap) right back into shape. A lousy brush will stay flopped over to the side.

## Paper

I use commercially prepared watercolor blocks for painting on location. They have their limits, but their advantages far outweigh them. Keep them small, 5" x 7" and 8" x 10"; larger ones are very hard to pack and start to add too much weight. A small painting can be made to look larger with a larger mat if necessary, but small works are much in vogue these days.

A commercial paper watercolor block has a thin layer of glue on all four sides. There is usually a two-inch space right at the top where there isn't any glue. To get your top sheet off the block after you have completed a painting, slip the tip of a knife (Swiss army is just perfect) into the opening, tip the blade up a little bit, and pull it toward you (almost like peeling an apple), cut the adhesive, and release the top sheet. Don't use a razor or an Exacto knife; they are too sharp and will slice the paper and possibly you!

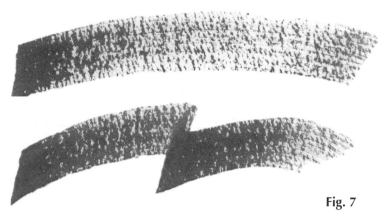

**Fig. 7**

*Strokes on different paper surfaces: rough...*

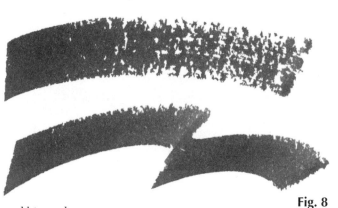

**Fig. 8**

*cold pressed...*

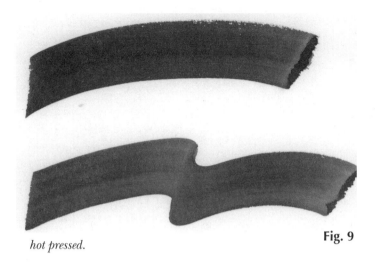

*hot pressed.*

**Fig. 9**

## Paper Surfaces

There are three popular painting surfaces for watercolors: rough, cold pressed, and hot pressed. Each has a different response to brush and paint and creates, therefore, a different final image.

**Rough (fig. 7).** As the name suggests, this paper has a very bumpy surface and will leave lots of white sparkles in your painting. Hard edges will appear softer because of the irregularities created on the bumpy paper.

**Cold pressed (fig. 8).** This paper has small bumps (think goose bumps). A less-bumpy good all-purpose surface, it provides little sparkles along the painted surface. Soft edges are not so fractured as on the rough paper (fig. 8).

**Hot pressed (fig. 9).** The surface here is very smooth (think ironed!). You can create crisp edges and sharp lines (fig. 9) not possible on the bumpier paper. Very little paper sparkle; good for strong one-stroke statements.

Try all three surfaces to see which one fits you best. You can get sample paper blocks free for the asking from most art-supply stores and you can try them out before you set out on the trail. They also fit very nicely in your kit for use as minipaintings.

Finally, if possible always buy 100 percent rag, acid-free paper. It will seem a little more expensive when you first start to buy paper, but like paint, high-quality paper is a bargain in the long run. Good paper is 100 percent rag and acid-free. The well-known paper companies sometimes offer sample papers; these are good to experiment with to find a surface you like. Some papers are more absorbent than others. I like a hard-surface paper where I can move paint around before it settles in. Other folks like a more absorbent paper where the paint stays put when you first put it down. It's all a matter of personal preference and experimentation.

## Pencil

You need a good drawing pencil. I recommend a 4B. It has a soft lead, good tonal range from light to dark, and is easily erasable. To sharpen the pencil, use the Swiss army knife or equivalent that most hikers carry. If you don't have one, a tiny pencil sharpener will far surpass clawing at it with your fingernails.

## Water/Containers

Unless you are planning to paint near a body of water, you will need to carry some water. (I've painted with ocean water and even beer—but clear tap or spring water works best!) If you are hiking you can simply use water from your drinking bottle. Otherwise, you need to carry some painting water. (Water is heavy—8.33 lbs. a gallon—so don't take too much, and learn the tricks of conserving your water and keeping it clean (more on that later).

My favorite containers are large plastic spice bottles, the type that carry oregano or parsley. They are about six to seven inches high and about two inches in diameter. They carry plenty of water and the top is big enough to act as a container for your paint water. It holds just enough to wet and rinse a brush, and when you've used up the water in the bottle itself, you should be done with the painting—otherwise you're probably overworking it. The small bottles that come in cosmetic cases are good, too, but always use plastic; it's lightweight, and there's no glass to break. Just make sure they are tightly capped or inside a resealable plastic bag. Test your container for leaks before you set out.

A little glycerin or salt will keep water from freezing if you are one of those hardy winter painters. Of course, snow or ice becomes water you don't have to carry if you have some means of melting it.

## Sponges

Include both natural and cellulose sponges, a small piece of each. You'll use the natural sponge for wetting your paper and "print-painting" trees, bushes, and generic growing things. You can get the best price at a hardware store; art stores charge a premium for theirs.

The cellulose sponge is for tapping excess water or paint from your brush. It helps keep your water clean if you wipe your brush off on a cellulose sponge or soft cotton rag before rinsing it in the water.

## Soft Cotton Rag

Some people prefer a small cotton rag to a cellulose sponge. In the studio I'll often use tissues, but old wet tissues are a nuisance to carry and could litter the landscape.

## Sketch Paper

If space permits, I like to carry a small sketch book or sketch pad (the handheld size, about 3" x 5") just to work out ideas, take notes, or whatever else comes to mind. Doing this on your watercolor paper becomes expensive.

## Piece of Red Acetate

I use red acetate to check the value pattern in a painting. "Value" is discussed more in chapter 3, but for now I'll say this: when you look at your painting through a piece of transparent colored material—red acetate, smoked glass, and blue bottle glass are examples—you see it as an assembly of light and dark areas of just one color. This allows you to judge whether the

overall light and dark pattern are balanced and pleasing to the eye.

## Camera

I usually carry at least one camera to take reference shots. A 35mm "point and shoot" or automatic-focus camera is great. With fast film (400 speed) you can take great shots from moving cars, trains, and canal boats. You can also just aim and shoot where obvious focusing would take too much time or create an awkward moment. I capture a lot with my camera, then work it into my paintings later. I have photos developed in 4" x 6" or 5" x 7" format for easy reference. Always carry extra film.

## Sunshade or Sunglasses

The sun at midday—the three hours either side of noon—can be a real detriment to painting. Sunglasses should be a gray/neutral tint so they distort color as little as possible. A sunvisor hat or sun bonnet will also shade your eyes and protect your head. Painting in direct sun is uncomfortable because the combination of the sun's brightness and the white paper are blinding. Try to find a shady spot.

## Bug Spray

A small squeeze-type bottle fits into your kit well.

## Easel

I don't use an easel, I paint in my lap. But there are lightweight, portable easels and chairs if you have trouble standing or sitting on the ground for long. However, these add weight and bulk to your journey. I prefer to locate a friendly wall, park bench, rock or log, and let nature provide my furniture as well as my inspiration.

## Old Credit Card

A credit card is handy for scratching out rocks, scratching in grasses and other "growies," and printing things like tree trunks, fences, and the texture on old boats or buildings. Specifics about this technique will be discussed in Chapter 4. It's the best use of a credit card I can think of, though you can also use the angled end of your flat watercolor brush for these effects.

## Empty Slide Holder

Take a slide that you don't want and pop the film out of it. Now you have a little 2" square of cardboard with a 1" hole in the center. Hold this miniframe up, close one eye, and look through it, just as you would look through the viewfinder of a camera to focus on an area or scene you want to paint.

## A Handkerchief or Tissues

Even the best watercolorists occasionally have allergy attacks or colds, and a misdirected and ill-timed sneeze can play havoc with a good painting. Tissues are also great for blotting out disasters before they dry.

## Heavy-Duty Rubber Bands

Two or three will help secure things against the wind and keep your supplies all together.

## Small Pump-Spray Bottle

It may seem a luxury to some but since I use one all the time in my painting, it's a necessity for me. It carries water that, when sprayed, will wet your paper for a wash, remove paint quickly, make a really great texture in a damp area of paint, or cool off your face and neck (see Specific Techniques, Chapter 4). These bottles are often found in cos-

metic cases for use as travel hair-spray containers.

By the way, cosmetic cases themselves make dandy watercolor kits. Toothbrush holders will hold paint brushes, pill bottles are great as water dishes (both the bottom and the top can be used), the little bottles are great for water, and the case itself holds everything except paper.

### Setting out and Settling down

Once you have assembled your portable kit, take it out on a dry run. Take a little walk or drive, locate yourself somewhere, sit down, take out your supplies, set up, and paint something. Now pack it all up again and ask yourself what you needed that you didn't have with you. Did you remember plastic bags? Is any water or paint threatening to escape? Did the wind get in your way? Do you need nine rubber bands to anchor things? Did your water spill? Is the container adequate? These are important things to discover before you go out on a hike or a trip. Spilled water or leaked paint is not a disaster of major proportions, but a little advance planning results in a lot of convenience, efficiency and, ultimately, nice paintings. I find that a quick setup and cleanup is essential for me, so I keep my supplies to a bare but efficient minimum and make do rather than adding more.

Finally, consider the following hints: Dress comfortably for the conditions. If you get very uncomfortable sitting unsupported, find a friendly rock or tree to lean against. If hard surfaces make you squirm, sit on the grass or carry an inflatable pillow. Learn to cope with bugs either by ignoring them or repelling them.

# Chapter 2

# Color: What It Is and What It Does

No book on painting would be complete without a discussion of color. It is one of the five elements of art and one of the key tools of the artist. The discussion of color here will be practical but tinged with the emotional and spiritual qualities of color as I have come to know them. For a fuller, more technical discussion see the books listed in the appendix.

## The Physical Properties of Color

The primary colors are red, yellow, and blue. They are called primary because they cannot be made from other colors, and using only them, you can create all other colors. The secondary colors, orange, green, and violet, are made by mixing two primary colors together. The primaries and secondaries together are the colors of the spectrum. The order in which they appear in the rainbow—red, orange, yellow, green, blue, violet, or "ROYG-BV," as some of you learned in grade school—is the same order in which they occur on the color wheel (fig. 10).

This order and positioning are important to understand because they will help you use color most effectively: mixing the colors you want, knowing which colors agree and which ones disagree, mixing a neutral without mixing mud!

| Primary Colors | Secondary Colors |
|---|---|
| Red + Yellow | = Orange |
| Yellow + Blue | = Green |
| Blue + Red | = Violet |

Complementary colors are opposite each other on the color wheel. They are:

red/green

blue/orange

yellow/violet

blue/brown (brown is technically dark orange)

When complementary colors are mixed together in almost equal proportions, they create a neutral tone that most often looks like gray. But whatever the exact hue, it bears no resemblance to the original colors.

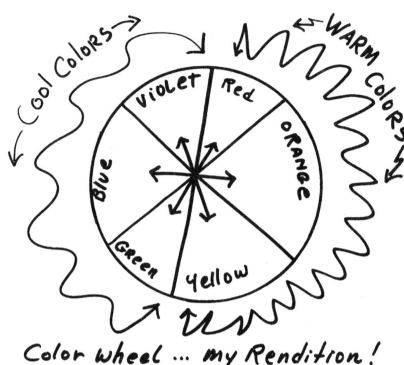

Color wheel ... my Rendition!

**Fig. 10**

This information is useful to the painter when an area seems to be too bright and needs toning down. An example might be a too-bright red barn that seems to be farther forward in a painting than the artist intended. The solution to the problem is to wash a thin layer of green over the red. Lightening it with water will only give you a pink barn. Using the complement will make it recede.

### What Colors to Use?

Before you dash off to the art store to buy more paint, let's take a look at what you really need and why. I prefer to limit the colors on my palette to a minimum—a variety of the primaries (especially two or three blues) and a couple of browns, for a number of reasons. Cost is a factor, but also I would rather mix my colors than buy every possible tint or shade. Mixed colors have a way of surprising you. Sometimes the pigments will separate a little in the most beautiful way, giving the painting a luminous quality you never intended. Also, you have far more control when you mix colors—if you practice first! For example, you can get the exact shade of brown-blue-gray for a stormy sea sky. No color like that can come out of a tube.

Here is a suggestion for a basic palette:

Primaries

    alizarin crimson

    Indian yellow

    gamboge, or new gamboge (clear bright yellow)

    French ultramarine blue (warm blue)

    Antwerp blue (cool blue)

Other Favorites (of mine)

    sepia (dark rich brown)

    burnt sienna

    yellow ochre/raw sienna

    olive green

    manganese blue

    burnt umber/Vandyke brown

For a bare minimum get the first five colors. If and when you can afford it, add the others.

Below is a quick list for basic mixes. Practice these before you start a painting; I can't stress that enough. Consider spending an entire afternoon or evening just mixing colors. Some variations will be breathtaking, others will be "learning experiences." Take notes as you mix, and keep your experiments in a little notebook for later reference. You will find some mixes you'll want to use again and you'll also find out which of the "learning experiences" you wish to avoid. (The words *transparent, semiopaque,* and *staining* appear in these color descriptions. See below for more about these properties.)

**alizarin crimson:** dark cranberry red, transparent color, somewhat staining

    *with* Indian yellow: great orange and peach tones

    *with* ultramarine blue: a plum-purple

    *with* Antwerp blue: a rich violet

    *with* Vandyke brown: a rich, warm dark tone when you need a dark that isn't black

**Indian yellow:** very strong yellow, goes a long way, semiopaque, somewhat staining

    *with* Antwerp blue: a clear bright green

    *with* ultramarine blue: more opaque olive tone

    *with* burnt sienna: a wild orange, good fall color

    *with* manganese blue: a light yellow-green, very pretty

    *with* Vandyke brown or burnt umber: a muddy earthy brown (great for river bottoms!)

**Antwerp blue:** a light cool transparent blue—I use it a lot

    *with* brown: nice gray neutral tones; with lots of brown and very little water, a good cool dark to use instead of black

    *with* yellow and a touch of brown: a good olive green

**French ultramarine blue:** A semi-transparent true blue or warm blue. Great mountain color!

    *with* burnt sienna: one of the most beautiful neutral/gray mixes; it goes from blue to rust with nice settle-out surprises.

## Transparent, Semiopaque, Staining

The terms transparent and opaque mean just that. Watercolor pigments are one or the other. What determines it is the size of the pigment molecule; the larger the molecule the more opaque the paint. I use mostly transparent, nonstaining colors so I can get out of difficult spots by layering more color or lifting color out with a sponge, tissue or wet brush. Transparent colors are like tinted glass. You can see right through them. They won't get muddy unless you really work at it. Their pigment molecules are very, very small, and the paint will actually float on top of your water for awhile rather than sink to the bottom. To test a color you don't know, touch a bit of color (try Antwerp blue) into a pool of clear water on a piece of paper. Watch how the color seems to explode all over the surface. That is what transparent color does. Opaque and semiopaques stay put. You can move them around and they will stay suspended in the water for a while, but they are more sedimentary...hence sedentary!

Staining colors do just that. They stain the paper and they are nearly impossible to remove. The worst offender of all is sap green. I don't know too many people who use it, precisely for that reason. It's a great color, but once it's down you are stuck with it for life. It is one reason that I mix almost all of my greens (I also like the variety I can achieve). Free color charts provided by paint companies will help you, but here is a quick guide for transparent, semitransparent, and opaque colors at right. (Staining colors are marked with an asterisk in the table.)

### Transparent
alizarin crimson

opera (a great fluorescent pink)

new gamboge, gamboge

alizarin madder

brown madder

manganese blue

Antwerp blue

Winsor violet*

sepia/sepia umber*

sap green*

raw sienna

thalo blue*

Prussian blue*

Payne's gray

burnt sienna

indigo*

### Semitransparent
ultramarine blue

cobalt blue

olive green

yellow ochre

Indian yellow

Winsor red*

mauve

cobalt violet

burnt umber

### Opaque
Chinese White

all cadmiums

   red

   orange

   yellow

cerulean blue

Naples yellow

As I said earlier, I try to keep my main colors transparent and nonstaining. (Incidentally, tempera colors and gouache are both fully opaque water-based paints. I don't use them at all, but lots of artists and graphic designers do. It's a very different look—flat surfaced and solid—not what I personally prefer.)

Use color intelligently as well as emotionally. We all have color habits. Some colors are almost signatures, as in the work of Rembrandt or Wyeth. Other times it's laziness or lack of imagination that makes us overuse a color. If you find that you are too limited or habitual in your choices of color, make yourself do a painting using only two or three colors, or use a friend's palette. Every so often treat yourself to a new and wonderful color that you've never seen or used before. (As always, test it out first! I bought a delicious transparent red one time, and happily squirted it into my palette prior to a trip to England. En route the wretched thing drooled all over my palette, out the sides, and all over everything—camera, hair dryer, etc. What a mess! Very transparent colors almost never harden and will slowly ooze anywhere and forever! Test them! Use them! But isolate them!)

Learn to see the variations in color and in value (the light and dark of it), and then experiment. And if you can't see them, invent them. Like Alice in Wonderland, who painted the roses red, we can change the nature of anything we wish. A green tree will have lots of different greens. We take green trees and purple mountains for granted visually. Look again at that mountain range. How many colors do you really see? How many dusky violets, plums, slate blues and royal blues are

there before the one that actually looks green? Count them. Now you are really seeing—because you are really looking.

When you start to see the subtle differences in color or value, then you can get more creative and start to push the colors into more personal directions. Try a familiar subject in "off the wall" colors. Try painting a red pine tree or an orange and red hillside. Accent your shadows with purple. It is not such a shocking idea—Try it!

## The Emotional Properties of Color

Warm colors are red, orange, and yellow—fire colors, if you will. Cool colors are green, blue, violet—water colors or deep woods colors. Overwhelmingly, warm colors appeal to the passionate emotions (my heart was on fire, red fury, etc.), while the cool colors suggest stability and calm and appeal more to our rational or intellectual nature. Warm colors appear to advance or come forward in a painting, while cool colors recede (it is possible to reverse that effect by using pure, intense cool color right out of the tube to contrast with warm colors that have been visually softened or muted by mixing them with their complements). Never use black to soften or tone down a color. Black will make a color dull and muddy. (You may notice it is not in my list of colors. I use it only rarely, usually combining it with yellow to get an interesting green.)

Dark, heavy colors in a painting evoke that kind of a dark, heavy, somber feeling. Light, airy, transparent colors suggest a lighter mood. Most desirable is a pleasing contrast and pattern of the two, which will be discussed

more fully in a later section on the principles of design as they are used in painting.

Landscape painting leans heavily on the cool colors (the blues, greens, and violets) and warm earth tones (the siennas, ochres, and umbers), rather than the most intense warm colors (fire-engine red, emergency orange, and neon yellow). Portrait painting relies more on warm colors for realistic flesh tones, often using complementary colors as undertones.

And now you are ready to move on. But I repeat, take some time to *practice* and *experiment* with color. You'll save hours of time and reams of paper in the long run. And who knows, some of those little experiments just might be the beginning of something exciting. The act of painting can be full of little miracles if only you let them happen, and more importantly, recognize them when they do.

Chapter Three

# The Elements of Art and the Principles of Design

The elements of art and principles of design are the most basic of our working methods. They are the things we use and the ways we use them to give us a painting that will look and feel good. They are the building blocks of a painting. We employ them in every piece we make. We do not, however, use them with equal emphasis in a given piece. In fact, there is a lot of overlap in the words as well as the concepts we use, which makes for some confusion. For example, take the terms *variety* and *contrast*—what is the difference? The two words are almost interchangeable, but there is a subtle difference and sometimes that difference is important. By the end of this chapter those subtleties will be clearer.

## The Elements of Art: The Building Blocks

The artist has only a few visual tools with which to practice his or her trade. They are line, shape, color, texture, and value. They sound simple and, in fact, they are. Here's how I explain it to my students. I suggest that you practice as you read (fig. 11):

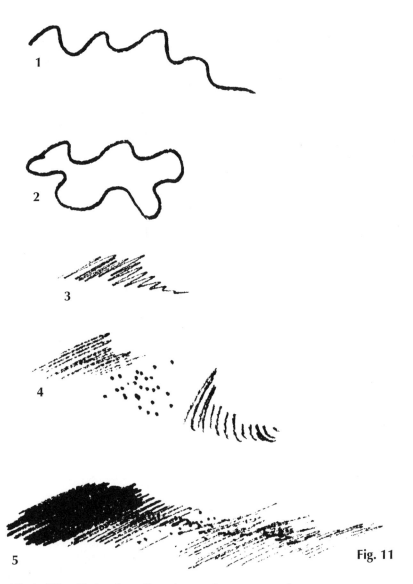

*The building blocks of art: line, shape, color, texture, value.*

1. Draw a line, any old line.

2. Turn that line into a shape.

3. Make a colored mark or marks on your paper (it's in black-and-white here—color it in if you like!).

4. With your drawing implement, make some textures by using dots or lines. And finally...

5. Add some value contrasts by making some very dark marks and beside them some very light marks!

And that's it! This is really all the artist has to work with, and it is as uncomplicated as it sounds. But a little elaboration and amplification will help.

## Line

Lines can be straight or curvy, sharp and crisp or fuzzy. They can be continuous or interrupted; expressive or merely used for delineation. A line will often define an edge—in that case, you don't actually see the line, you just see the object stop. (See the bibliography for a list of books offering a fuller discussion of line.)

## Shape

There are two basic kinds of shape: organic and geometric. Organic implies a *living* shape, one that looks like it is growing or has grown. Often it implies curvy and irregular edges. Geometric shapes are those that are predictable and hard-edged. Landscapes most often have organic shapes. Even rocks, while hard-edged and irregular, are organic. The human form is an organic shape. Man-made objects and some crystals are often geometric—think of buildings, boats, and fences.

## Color

A more detailed description of color is found in Chapter 2. At this point, suffice it to say we all have preferences and so do our viewers.

## Texture

In the visual arts texture refers to either the visible surface of the object the artist is depicting or the surface of the paper or canvas itself. You can imply it with your materials (suggesting the rough bark of a tree or the smoothness of glass using only your paint) or you can apply it by somehow disturbing your working surface— scratching it or embossing it, for example. Anyone who has placed a paper over a coin and rubbed the paper with a pencil to make an embossed print of the coin surface understands texture.

## Value

Value conveys the light and dark of things. It's easy to understand, very difficult to apply. A black-and-white photograph has light areas, dark areas, and middle areas. It is white, black, and gray. The problem comes when we try to apply these principles with color. Strong value contrasts can make a good painting come alive. It's the pattern of lights and darks in a painting and not necessarily the color or the subject matter that makes the difference between a ho-hum painting and a real dazzler!

These five elements of art—line, shape, color, texture, and value—are all you will be using as you respond to the natural world in a painting. Later I will be quite specific in my explanations and demonstrations of how you may use them to create art, but this is a place for you to start—a base of understanding.

## The Principles of Design: The Plan of Action

The principles of design are the orderly way in which we use the elements of art. While there are many words that refer to the principles of design, I have chosen seven as the most basic and easy to understand, and therefore the most easy to apply to your own work.

Let's look at the principles one at a time. The seven are repetition, rhythm, variety, contrast, balance, harmony, and unity.

These principles are the way we work with our elements. I can *repeat* a line, for example, or a shape or a color

to give *unity* and *harmony* and *balance* to something that I am designing or planning. Anyone who has designed a flower garden or decorated a room knows what I mean. Designing a painting is not really any different. We plan where our light and dark and big and little shapes will be placed in the overall composition. This is where the artist has it easier than the photographer. The camera takes what it sees. The artist can move a tree or a mountain to suit the composition or the plan of action.

## Repetition

In painting, successful repetition is the use of a shape, color, line, or texture often enough to give a sense of connectedness or unity, but not so often as to look like wallpaper! Repetition is a tough one; easily understood but just as easily overused. To use the analogy of the flower garden again: a garden with all of the same type of flower, or having flowers of all the same color or shape, would be visually boring, however bountiful or sweet smelling it might be.

Repetition is very comforting. It is something familiar, like the repeated chorus of a song or nursery rhyme. Repetitions in painting are visual handlebars; they are something to grab and hold, and to use but not to overuse. Figure 12 shows an effective use of repetition while figure 13 is overdone.

**Fig. 12**

*A good use of repetition.*

*Getting carried away.*

**Fig. 13**

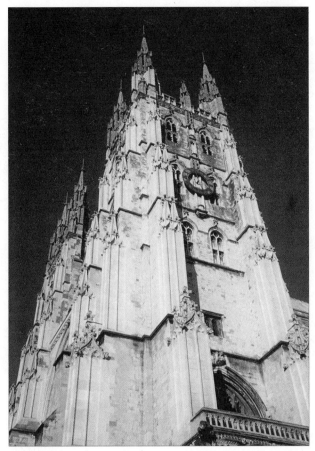

*Canterbury Cathedral's façade shows the*    **Fig. 14**
*beauty of rhythm in architecture.*

### Rhythm

Something that is repeated at regular or predictable intervals gives a painting rhythm. Like repetition, rhythm is comforting and familiar but can easily be overdone: The gentle rhythm of waves heard at night is soothing, the dripping of a faucet is maddening.

Some paintings are more rhythmical than others. A nice example of a circular rhythm in painting is van Gogh's well-known painting, "The Starry Night." In architecture, examples of rhythm are easy to recognize. The façade of Canterbury Cathedral (fig. 14) shows how repeated and alternating shapes create the feeling of ascension into heaven and maintain a unified, whole image to the observer.

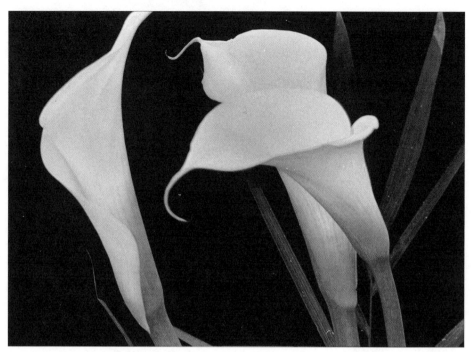

*A measured juxtaposition of lilies creates variety.*                    **Fig. 15**

## Variety

Vary your compositional shapes enough to be interesting, but not so much as to be hodgepodge. Vary the sizes, shapes, and intensities of value within the context of your painting and the confines of your message. If you are communicating visually the right amount of variety can emphasize your subject, but too much will dis-tract. Our flower garden would be more pleasing with a selection of different kinds of plants blooming at different times of the season than it would be if it had one each of two hundred varieties all blooming at once. The simple grace of the calla lilies in figure 15, for example, is lost when they are combined with the more-complicated daffodils in figure 16. A landscape painting that depicted moun-

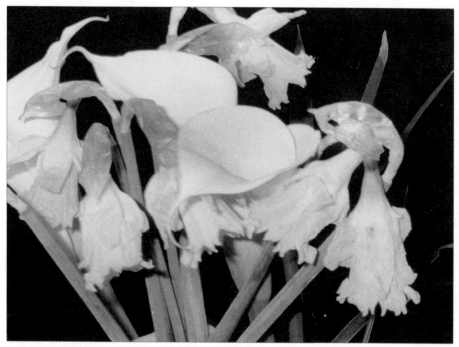

*Too much variety produces chaos.*　　　　　　　　　　**Fig. 16**

tains, a stream, trees, clouds, a storm, flowers, and a lake all on the same piece of paper would be a similar visual mess.

## Contrast

Contrast involves the juxtaposition of differences. In our hypothetical garden it could be a garden sculpture: bright accents of color or texture in an otherwise muted setting, or the singular green shrub in an otherwise floral area. Repetition is soothing and comforting, but too much of it is deadly. We need some repetition for unity, but we need contrast for interest.

Contrast can come in color or in value (darks and lights) in a specific setting. It's the visual surprise that makes the painting work.

*One large shape can be balanced by several smaller shapes located in another area of the painting.*

**Fig. 17**

## Balance

Balance is the orderly arrangement and use of shapes and colors within a composition. There are many ways to achieve a feeling of balance. Color, for example, has visual "weight." Put a bright red object right next to a bright yellow object of the exact same size, and the red object will look and feel heavier. Mass and density also affect balance: massive solid shapes (tree trunks, rocks, mountains) have more visual weight than large masses of snowflakes, leaves, or clouds. What you want to achieve in your work is a pleasing visual balance. An old trick is to turn the work upside down and view it as just shape and color. This will help you as you check your own work for balance. Another trick is to look at a painting in a mirror. Does it look or feel too heavy on one side, or in the middle, or at the top or bottom? What do you need to do? Does it need more of something? Less of something?

These are the questions you must continually ask yourself.

When decorating a room, you don't put overstuffed furniture in a tiny space, or all the chairs, sofa, piano and pictures along one wall and nothing anywhere else. The result would be unbalanced. In planning a garden, you put the shorter plants in the front and the taller ones in the rear. Keep it in mind as you plan your painting. Figure 17 shows a well-balanced composition: the larger shape on the left is matched by the group of smaller shapes on the right.

## Harmony

Voices harmonize, colors harmonize. When there is harmony in a family or in a relationship, it means the people get along. Do the objects in your painting "get along?" A skyscraper does not belong in the middle of a landscape. Do your colors get along? Do you have too many contrasts? Are there too many ingredients in your stew? Are you

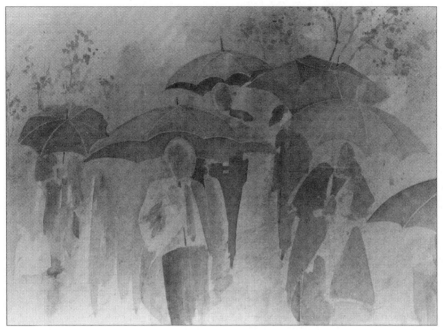

*"Rainflowers."*                                                                **Fig. 18**

trying to blend won ton and chili? The result will be indigestion! Choose your theme (content) and your color scheme (basically warm or cool) carefully. Eliminate the unnecessary and you have a good start toward a harmonious piece.

## Unity

Connectedness.

If you've applied the first six principles correctly, the unity will happen all by itself. In this context the principles of design are really no mystery at all. At least they aren't for me anymore. And I hope they make more sense to you. If you realize that you are using them all the time, then seeing and using their lovely order in your artwork will come naturally.

In an earlier part of this chapter, I discussed the elements of art as the basic visual tools of the artist. How the artist uses those tools results in a work of art (hopefully!) called a composi-

tion. A composition or finished piece is planned (designed) using the principles of design much the same way you plan and design the decor and arrangement of a garden or a room or even a meal.

I usually apply the principles of design at the *end* of my working process. Sort of like the old adage, "When all else fails...read the directions!" But for me, too much planning and ordering of the process before I start would probably get in the way of my creative process. For other painters, it *is* their creative process. One method is not better than the other, only different.

Let's look at a painting, one of mine (fig. 18), and review these terms with something concrete to hang them on. That way, while they are still fresh in our minds, we can see them in action.

The painting reproduced here in black and white is called "Rainflowers."

The overall color scheme is cool, and its predominant colors are blues and greens.

Let's start by looking at the composition itself. It's really a people/umbrella-scape, inspired by the annual outpouring of media photographs on this theme every April plus my own sketched memories of walking in rain-crowded, mist-shrouded parks in central Paris.

Look for the principles of design and how I have made use of them. Repetition is found in the shapes of the people but most of all in the umbrellas. It is those shapes you first see when you look at the piece. The people shapes are vertical, of smaller, vaguely geometric shapes, and the umbrella shapes are really the horizontal element in the piece, providing the main direction of movement. And even though the two shapes repeat, they also contrast with each other. The vertical thrust of many repeated people shapes contrasts with the horizontal, darker-appearing umbrella shapes.

These two main themes appear quite dense against the airy and fragile shapes of the trees in the background and this provides more contrast. Another contrast that can be seen in the color print is the touches of pink and yellow ochre found here and there throughout the painting. The background was an abstract slosh of cool color that I applied leaving lots of white chunks. I drew and then painted my figures into and over this first shape, letting it finally become the background that set the mood and unified the whole piece. The harmony is in the use of color and the cool tones, and the unity is how the whole thing comes together to tell the story: cool tones, rainy day, umbrellas, etc. A pleasing balance exists between solid shapes and negative spaces. And the rhythm of the advancing umbrella shapes takes full advantage of the planned repetitions.

When you are working on your own painting and you apply these principles more specifically to your own work, or to the work of other artists as you encounter it, all of this analysis will become a clear and unified whole. The effective use of contrast can make a painting sing, attract a judge or customer, and win a prize. Paintings attract attention when they have a strong pattern of lights and darks. Bland paintings get passed over. I can say this from direct experience. When I have been asked to judge art shows, I've noticed it's the high-contrast paintings that collect most of the prizes.

You are ready to begin painting. The next chapter is called Specific Techniques. It will take you step-by-step through ways of painting many of the things you find in nature and will want to make part of your landscape paintings.

Chapter 4

# Specific Techniques and Approaches to Landscape Subjects

In this chapter I will describe the two most commonly used methods for applying watercolor paint to paper. I will demonstrate and compare the wet-in-wet method of painting with the more direct method of painting using layered washes of color on dry paper. With those as a basis for your thinking, I will go on to show you ways of seeing the elements of a landscape in a new way that will shake loose those old images clouding your vision. Finally, I will demonstrate ways of rendering the individual elements of a typical landscape painting using both those methods of painting. I will show you how to paint different kinds of trees, land and water surfaces as well as "the wild blue/gray yonder," using both the wet-in-wet method and the direct method of painting on dry paper.

## Two Approaches to Painting With Watercolor

There are primarily two ways of working with watercolor: one is on wet paper, the other is on dry paper. The wet approach, often called wet-in-wet, takes more explaining because there are degrees of wetness and each has a different result. Describing the dry-paper technique is easier, because when you are working on dry paper, an area is either dry or it isn't.

### Wet-in-Wet Painting

Painting on a paper whose surface has been wet thoroughly with water so it looks shiny will produce a blurred, fuzzy, and often surprising image. Instead of a line or a shape determined only by you and your brush, the line or shape you set down will be altered by the water already on the

paper. The water carries and spreads the molecules of paint, allowing them to flow outward from the original line into a new and often delightful direction. On very wet paper, the paint slides around and can be manipulated fairly easily until it starts to "set up" (to dry). Eventually (and with practice, there's the magic word) you will learn just how far to take it, and just what ratio of water to paint will produce what result. To this you might add gravity: hold your paper upright or sideways for a directed flow, and the results will again delight and amaze you. Eventually they will be predictable.

Too often the temptation is to interfere with this process and try to control the surprises. It is better just to let it go and be surprised. For example, don't fuss with a wet sky until it has dried completely. When it has dried, you can make minor adjustments or actually float another whole wash over the first one.

You will learn how to make these seemingly spontaneous occurrences exactly where you want them— planned serendipity.

**Damp Paper.** Damp paper, not really soaking and shiny wet, but simply moist, has a very different response from really wet paper. The edges of a stroke or shape will blur or fuzz, as on a blotter, but the water and color from your brush will be absorbed at once and the image will be difficult to adjust and almost impossible to remove. I don't ever use damp paper although many artists do. I need to be able to lift out a color, or a whole tree or mountain if necessary, or darken an area until I consider the piece completed.

### Painting on Dry Paper

This is sometimes called direct painting or the "English method," using thin-layered washes of color that are allowed to dry completely between coats.

Painting on dry paper is just that. Usually the artist begins with a light drawing on the paper and then goes on to apply (or "lay in") areas of color as the drawn image dictates. An image painted on dry paper will have more distinct edges and be more sharply defined than will an image painted on wet paper.

Usually this method of painting is done in several stages, starting with middle values of colors that are not too dark or too light. If you start out too dark your painting will have a heavy, muddy appearance that will be hard to adjust later on. Starting with middle values lets you add dark areas when you are ready, using them as accents and focal points—which is what they should be. White and light areas are usually left as dry paper and are planned out at the drawing stage of the painting, before you ever touch the paint.

*Brush stroke on wet paper.*

**Fig. 19**

*Brush stroke on dry paper.*

**Fig. 20**

## Comparing the Wet and Dry Methods

Compare some examples of lines and shapes actually painted on both wet (fig. 19) and dry (fig. 20) paper. Note the differences so you can decide which you are most comfortable with and which to use when. In some situations a combination of the two is appropriate. The contrast of soft-edged and hard-edged shapes and images can have a profound effect on the finished piece.

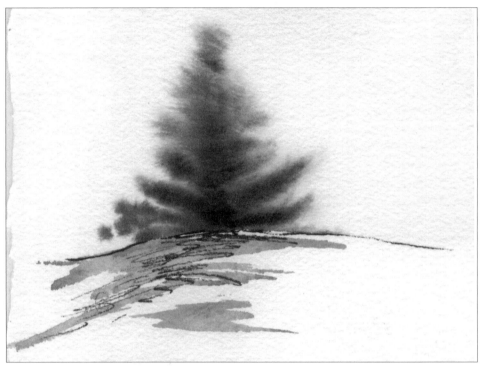

*Painted tree on wet paper.*                                    **Fig. 21**

I will use a pine tree shape to demonstrate the differences between wet and dry paper as well as an example of the combination of the two. I find that when I can see the shape of something I will actually be working with I understand it better than using abstract shapes or lines.

Let's look at a pine tree shape "touch" painted with the edge of a 1"

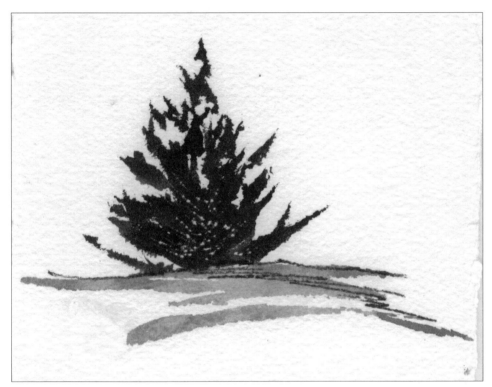

*Painted tree on dry paper.*

**Fig. 22**

aquarelle brush, first on wet paper, then on dry paper. We use a flat brush because pointed brush tempts the beginner to 'draw' with the point. A flat-edged brush makes you paint because you just can't draw with it!

Note that the pine tree painted on wet paper (fig. 21) has soft edges and indistinct lines. The tree painted on dry paper (fig. 22) has what we refer to as hard edges, and the appearance is very crisp.

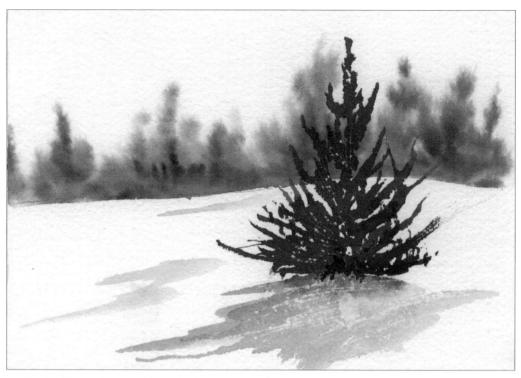

*A pleasing blend of wet and dry techniques.*                    **Fig. 23**

The next illustration is an example of the contrast between the two techniques (fig. 23). The background line of trees was painted on wet paper. I drew a horizon land line across the lower third of the paper. Then I wet the paper with clear water down to the land line only, letting no water seep below it. I touched in my tree shapes by tapping them into the shiny water and letting them blur and run themselves into a background. When the paper was completely dry (I used a hair dryer, but in the field you can just lay it in the sun for awhile), I added a foreground tree in a much darker value (same color!) and suggested a few lighter-value shadows with whisks of my brush on the dry foreground.

You can see how the background trees, because of their indistinct lines and lighter value, really look like background. Notice also how the crisp edges and darker value of the tree in the foreground make it look closer to us. This is how we see. The edges of faraway things look less distinct to us and close up things are in sharp focus. I will describe this combined technique in much greater detail in Chapter 9 when I demonstrate how to paint a snow-covered tree.

With this concept of the two ways of applying paint to paper as our foundation, let us learn how to look at and really see some of the individual components of a landscape painting.

*"Dancing Water." Collection of A. Carmona.*                    **Fig. 24**

## Seeing Your Subject

In this section I will introduce you to a way of really knowing the subjects you are planning to paint. Students continually ask me how to paint a tree, a mountain, a waterfall, or whatever else is confronting and confounding them at the moment. My students often think there is an individual formula for each subject—a specific stroke, color, etc. There is, but it is not what they think it is.

Unlike traditional Chinese painting, where the student artist learns specific strokes for subjects (sometimes as many as forty or fifty for trees alone!), the western artist's job is to look at patterns and/or characteristic shapes, and represent them as he or she chooses,

leaning heavily on personal style or interpretation.

I was reminded of this when a group of students asked me to paint a waterfall for them so they could see how to do it. Water is not one of my preferred subjects and moving water can be especially tricky. Instead of worrying about individual trickles and bubbles, I looked at the whole scene. I sketched the big pattern of the water, and lightly located the surrounding rocks and trees. By keeping my attention focused on the patterns—the large and small shapes, the light and dark areas—rather than each and every pebble and bubble, I was able to paint a very effective, and plausibly moving, waterfall (fig. 24).

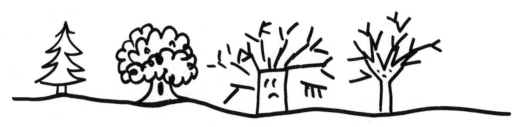

*Stereotypical trees.*

**Fig. 25**

### Stereotypical Seeing

All of us have visual patterns in our heads. Tree shapes are some of the most obvious. Ask almost any person to draw a pine tree or Christmas tree and invariably he or she will draw the pattern of descending triangles so irritatingly familiar to all of us. If we press for another tree drawing, we will get one of the following (fig. 25): Here we have the triangle tree, the broccoli tree, the Van de Graaff-generator tree, and the flying V tree. Do they look familiar?

Without looking out of the window or studying the tree you are leaning against, draw the trees in your mind—all of them that grow there. See what tree patterns are in your head. This is an important step in really seeing trees later on, because if you don't identify your own specific stereotypes you won't be able to rid yourself of their influence in your work. Once you have really looked at your own stereotypes, you are ready to look at and see real growing trees.

## Air Drawing

Go find a tree, any tree will do. Shut one eye and extend your writing arm fully. Point your index finger and 'air draw' the outline (contour) of the tree (fig. 26). Start at the bottom of the tree and trace the outline, first up the trunk and then very slowly follow the exact wrinkly, curvy, convoluted outline of the foliage pattern (or in winter, the branch pattern) all the way around the top and slowly down the other side of the trunk, and finally back down to the ground. Resist the urge to rush this exercise. Go very slowly so you are really looking and seeing.

In this way you have felt, viscerally, the shape of the tree. Doing this with a pencil on paper is called contour drawing (the drawing looks sort of like a cookie cutter when it's finished). It is a way to really see the outline and basic shape of a tree. Find another tree, a different species, and try it again. Do you see and feel the difference in their shapes? You should. Now consider the differences in the shapes of apple trees as compared with poplars.

An air drawing of anything will help you really see the subject by first feeling it. Doing it slowly with the extended arm, takes the movement from your eye, into your finger, down your whole arm and into the center of your body. Seeing it by feeling it is the first step to drawing and then painting it, whatever "it" is.

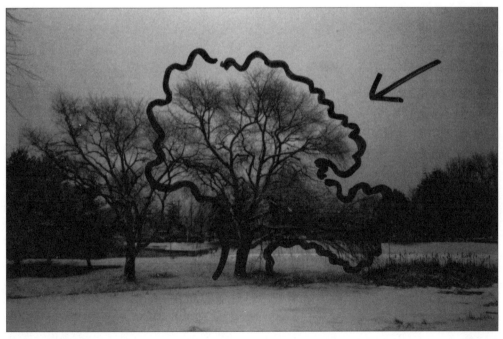

*Really see that contour...*

**Fig. 26**

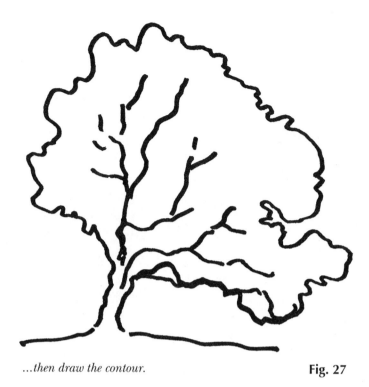

*...then draw the contour.*                    **Fig. 27**

## Contour Drawing

After you have practiced air drawing, contour drawing should be easy. As with air drawing, the trick is to do it slowly. The natural tendency is to rush the process, to go too quickly. When you do this, you will snap right back to drawing your stereotypical tree. You'll really have to fight it.

Hold your pencil loosely and, just like the air drawing, start at the ground. Slowly work your way up one side, wobble your way all around the outside of the foliage and branches, then inch your way back down to the ground. Now look at what you have done (fig. 27). Feel and see those shapes and carefully note their differences. The proportion of branch shapes, foliage shapes, and air spaces between the clusters of leaves are just as important in describing the tree as

is the outline. In time you will learn to see and render it all, or as much as you want.

Besides looking at a tree's shape, you should also look at the proportion of foliage height to the height of trunk that you can see. Note in the illustration that the proportion of foliage to trunk is one-fifth trunk to four-fifths foliage. An old pine tree that has lost many of its lower branches to snow weight and lack of sunlight might be just the reverse—one-fifth foliage and four-fifths trunk.

The point is that each tree is different, and while a given variety of tree will have a characteristic shape (compare, for example, figures 28 and 29 with figures 26 and 27), we need to learn to see the specifics first before we really draw or paint them.

*Different tree species have different shapes...*    **Fig. 28**

*which the contour drawing shows.*    **Fig. 29**

### Negative and Positive Shapes

After you can see, feel, and draw a contour, you need to see the smaller shapes within the big shape—the positive shapes (the foliage bunches) and the negative shapes (the spaces where the sky shows through). They will alternate to create the tree pattern that we recognize. The negative spaces are as important as the positive shapes to the overall shape of the tree. Learn to see them and keep them in their proper place.

### Taking Brush in Hand

#### To Paint a Tree: The Dry-Paper Method

I hope I have set the scene for you to begin. Now let's look at a variety of specific subjects common to landscape painting and the techniques for painting them using both the wet and dry methods. We will start with a tree similar to the one used for air and contour drawing. Please read through all the steps at least once before you start. It will help your timing later on. (Note: I used d'Arches 140# cold pressed paper for all the sample illustrations in this section. You might want to practice on a comparable sheet.)

**Step 1.** First, air draw your subject. Then, on a dry piece of paper, lightly sketch in the tree shape as you see it, keeping in mind proportion, contour, and subshapes (fig. 30).

**Fig. 30**

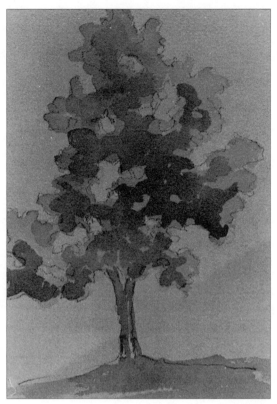

**Fig. 31**

**Step 2.** Using your 1" aquarelle brush and a middle value of your color, touch in your major foliage subshapes (fig. 31.). The color depends on the type of tree and the season; try a light yellow/blue mixture of green.

**Step 3.** While the patches of color are still wet, use a darker value of your original color (darken with more blue), to touch some darker color into the shadow side of the shapes and along the bottom (fig. 32).

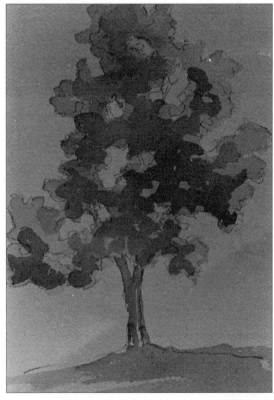

**Fig. 32**

**Step 4.** Using a middle value (the color depends on the type of tree, time of day, season, and proximity of other trees), draw/paint in your trunk shape and add the branch shapes you see. Remember, you can't see all of the branches all of the time. The leaves get in the way.

You may notice that some of the leaves look lighter than others. This is because the top or outside leaves catch more light than the ones lower down or closer to the trunk. You can achieve this effect by painting the tops of the clumps of leaves or needles in a lighter value than the ones underneath that are in shadow.

**Step 5.** While the painting is still wet, touch in a darker value along the shadow side of the trunk and at the bottom of the branches. Darken your color with more of either color—your choice. White or dry spots left in your branch shapes will look like sunlight falling on your tree. You can achieve this effect simply: just leave the areas you want to be sunny free of paint.

When all this has dried, add some dark "boinks" of color for emphasis and visual impact (fig. 33). That's what really happens in nature—contrast!

You might want to keep a notebook or sketch book of your trees to show your progress. A small one will fit right in your pack and won't take up too much room. It will also serve as a valuable reference later on when you need a quick tree and you don't want one of those little stereotypes to crawl in when you least expect it.

So, now you have really experienced a tree. In the past, you may have looked at the landscape but you may not really have seen it. Go over this sequence again: recognize your stereotypical mind pattern; air draw the outline of the actual tree; contour draw and then shape draw (negative and positive) with a pencil; and finally, paint the shapes and values of your subject.

## A Tree on Wet Paper

I showed you a tree done in the wet-in-wet method of painting earlier in the chapter at the end of Section One. To remind you, I will now show you a step-by-step painting of a tree done in the wet method to compare with one done on dry paper. Note that it has the same overall shape, but also note the differences in edges and the more subtle value differences in the wet method.

**Step 1.** Lightly draw in your tree just as you did for the dry method (fig. 30). Pay attention to the overall shape and to the negative and positive shapes created by the branches and the leaves.

**Step 2.** Wet the paper using enough water so the surface of the paper looks shiny, but not so much that it is running off all four sides.

**Step 3.** Load your 1" aquarelle brush with a middle value of a soft green touched with either a little brown or a little blue and touch it into the leaf areas you have just drawn. If the color explodes and loses all definition of

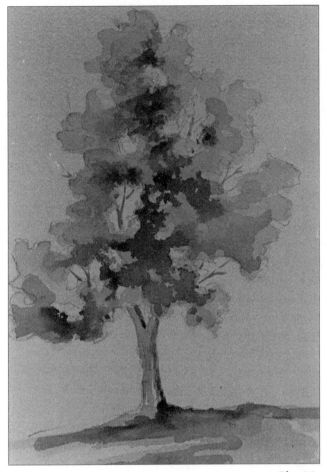

**Fig. 33**

shape, your paper is too wet. Wait a little bit until the surface is not so shiny and try it again.

**Step 4.** As the first colors are just beginning to lose their shine, go back into the lower areas of the leaf-clump shapes and touch in a darker value of whatever color you started with. If it was blue-green, add some more blue. If it was brown-green, add some more brown.

**Step 5.** When it is a little drier still, touch in the trunk and branches of the tree. Use a middle value of a gray tone that you can get by mixing blue and brown together. Because your paper should be almost dry at this point, the branches will not fuzz out the way the

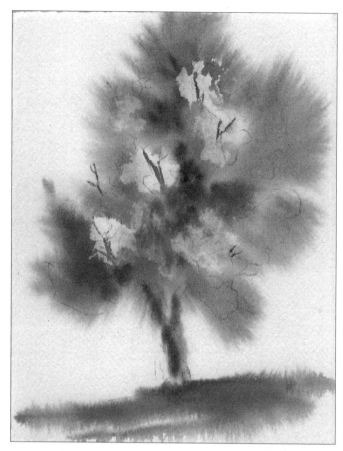

*Step 5: Branches added to a tree painted on wet paper.*    **Fig. 34**

leaf areas did when you first applied the color to them (fig. 34).

Remember that Rome and trees were not built in a day, and practice this a few times. While this method of painting allows for some delightful surprises, it takes a little experience before those surprises are somewhat predictable. They can and will be.

### Tree Colors

Before I leave the subject of painting trees I will give you a few of my favorite color mixtures for painting trees. Eventually you will come up with just as many of your own, but here are a few to get you started.

The rule of thumb (or brush) is to use lots of colors. Summer trees have three to six shades of green. The lightest one can actually be pure yellow, and you can work your way into deeper shades by adding blue, green, brown, or even a little purple to the basic leaf green.

For fall foliage, start with yellow or orange, then add some red and/or burnt sienna (a deep burnt orange) and finally a dark brown in the shadow areas. Unless you are painting birches, paint your tree trunks in middle values of a mixed gray. Use a blue-brown combination, or try mixing a red-green gray using alizarin crimson and viridian or Winsor.

Winter trees are either bare or they are evergreens. For leafless trees, experiment with shades of gray. Evergreens are usually combinations and values of a dark sage-blue-green. Mix blue and green and add a little purple to produce this green.

If you come upon a color blend you like, write it down. That's what your notebook is for. It's easy to forget your genius blend a year later when the perfect scene presents itself and the sunset light is fading faster than you can mix it by trial and error.

## Skies and Clouds

The painting of a sky is a glorious thing. The artists of the Renaissance had their apprentices do it. The painting master or mistress concentrated only on the subjects and sometimes on just the main subject. Jacob van Ruisdael, a Dutch painter of the 1600s, painted magnificent skies, yet he hardly ever left his studio to work. Instead he painted from memory and impression. And speaking of impression, Renoir and Monet painted their skies, often working beside each other, with unmixed dabs of color, side by side on the canvas, to produce that vibrant luminosity characteristic of the Impressionist period. Get thee to a museum and look at other peoples' skies, but first get thee out and really look at your own—and *see* it, for only then can you paint it.

Look at the sky and notice, if you please, a few things. If it is a clear day the sky directly above you will appear a more intense blue than at the horizon. That is because as you look straight up there is less atmospheric debris, moisture, dust, pollen, smog, etc., to see through than when you peer out to the more distant horizon. (This also

explains why objects near us look more intense in color than objects in the distance. See the section on mountains beginning on page 66.

Skies have almost as many colors as you have on your palette. Blue and gray are easy to envision; so are sunrises, sunsets, and the postsunset glow of deepening smoky lavender. But skies also can be green; just ask any midwesterner who has experienced a tornado. They can be yellow; a heavy morning ground fog with a clear sky behind it will produce a yellow sky just before the sun breaks through. And of course, you can create any color sky you want, to fit your or your painting's mood. Here's how, using both the dry-paper method and the wet-in-wet method.

As always, think about and feel your sky before you paint it. Is it background or a focal point? It can be both—but not in the same painting. If it is to be a setting or a background for the subject, it should be almost a plain wash—not too dramatic in color, movement, or pattern. On the other hand, if it is to be the focal point, you can be as expressive and dramatic as you wish. Some very effective paintings are mostly sky—it will be your choice.

Speaking of color, I should also say that any sky is enhanced when you use more than one color. Remember to use analogous colors—colors found next to each other on the color wheel, or all warm or all cool colors—in a sky. If you mix complementary colors (those opposite each other on the color wheel), you will end up with a gray muddy sky where you might have intended drama and intensity. (There is one way you can use opposites: keep them separate and only let them blend at the edges.)

## Skies on Dry Paper

"Dry skies" might feel rather anticlimactic, but believe me, they are not. A sky painted on dry paper brings out the natural sparkle of dry paper to create clouds, textures, and patterns that can be a real delight. Here the artist is directly responsible for the "flow" of the sky. You have much more control over what is happening than you do using the wet-in-wet method. You might try using more than one color at the same time on your very biggest brush. That's a nice way to achieve a pleasing sky. For example, two different blues, or a blue and a lavender, will make an interesting statement.

The first step is still to think about your sky and the role you want it to play in the overall painting. Feel that sky before you start to paint it. The decisions you have to make are the same ones as in the wet technique but the results will be crisper and more contained.

For examples, I have printed two slightly different skies, both on dry paper. In the first (fig. 35) I have used mostly horizontal connecting strokes,

*Sky using horizontal strokes on dry paper.*                    **Fig. 35**

*Sky using diagonal strokes on dry paper.*                    **Fig. 36**

leaving very little white paper showing with the exception of the natural white where the brush skipped over the surface of the paper. In the second one (fig. 36), I used slightly more diagonal strokes that are not as connected as those in the first example. The result is more white spots in the sky, and the diagonals suggest more cloud action.

Start by comparing these two paintings. Note that one is very horizontal in its structural movement and the other is more diagonal. The horizontal sky is more restful, while the diagonal sky has a more dramatic appearance.

Another semidry sky technique involves lightly spraying the sky area with a spray bottle. Paint the sky using

*Sky using a spray bottle to wet paper a bit before applying paint.*  **Fig. 37**

the same strokes as if the paper were dry. The result (fig. 37) is a softer sky than the totally dry method, but you have a little more control than with the wet method. (Actually, this can be a whole painting technique if you apply the spray to the entire paper before you start to paint.)

*Sky using horizontal strokes on wet paper.*

**Fig. 38**

## The Wet-in-Wet Sky

Wet the sky area of your paper with water and, using a "loaded" brush (a brush loaded with color), swish long horizontal strokes of that color into your sky area. Leave some white spots. You can lift the paper and tilt it to an angle and let your color run and slide. You'll notice that the sky is really creating itself (fig. 38). Don't argue with it.

Note that in the illustration of the wet-painted sky, the color has fuzzed outward in all directions, creating the image of soft billowy clouds. The

*Sky using gravitational effect on wet paper.*

**Fig. 39**

second illustration (fig. 39) is more dramatic and directional. Because I held the paper at an angle while the sky was still runny wet, the color flowed in the intended direction (up and down), giving the impression of a stormy sky.

Another effect you might want to try: flick a little water into your sky just as the water in the sky is losing its

*Flick a little water in your sky for texture.*

**Fig. 40**

shine. Note the light splotches in this sky (fig. 40). I waited for the sky to dry up a little bit—enough that it was still damp but would no longer run—then I flicked a few fingers full of water into the drying area. This created texture in a sky that was too flat, giving it the effect of snow or rain in a stormy, dramatic sky. Some colors will do this better than others. The very transparent ones do it best—Antwerp blue and Payne's Gray, for example—while the opaque colors remain unmoved.

## Clouds and Cloud Formations

First, a practical hint. If you got carried away with your brush, and you really intended to have some clouds in that sky but forgot to leave some white areas—or it all ran into itself—and your best intentions disappeared, all is not lost. While the sky is still shiny wet, take a lightly crumpled fluff of facial tissue and gently roll it around in your sky. The tissue will pick up a lot of color, and your clouds will appear pretty much where you had intended them to be (fig. 41). Like the water splatter in the wet technique, facial-tissue clouds have saved many a sky. The secret is to roll the tissue around, then discard it. Don't pound a tightly wadded lump of tissue into your sky and expect clouds; all you'll get are tightly wadded clouds. Keep it loose—like you want your sky to be. If a brush hair or bit of tissue should lodge itself into your sky, leave it there until your sky is dry. It will disappear—it will fall off when the paper is dry—but if you pick away at it as you do a hangnail, you'll have the equivalent of a hangnail in your sky—an unpleasant little mess. Restrain yourself!

*Clouds created with facial tissue.*

**Fig. 41**

## *Sky Colors*

Blue is always the first sky color that comes to mind, but it is not the only color of a sky. There are in fact almost as many sky colors as you have on your palette and you should use them.

For blue skies, I favor light values of either ultramarine blue, cerulean blue, manganese blue, or Antwerp blue. The last two are my favorites because they are very transparent and I can get them off the paper if I decide that they are not quite what I want.

I always mix the grays I use for sky. I use mostly a blue-brown mixture of Antwerp blue and sepia. These two give me a cool transparent gray that is very flexible. The sepia, however, is a staining color, so watch out. You may have it in your sky forever if you are not careful.

For the lavender of an evening sky, I like the blend of Antwerp blue and alizarin crimson.

Sunset skies are effective when you use yellow ochre and alizarin crimson. The yellow ochre is softer than Indian or cadmium yellow, and it doesn't stain the paper.

For a truly dramatic, morning-after-the-storm sky, try first washing a few sweeps of yellow ochre into a wet or dry sky. Then brush a light value of either Payne's Gray or Antwerp-sepia gray around the yellow ochre streaks. The yellow ochre and the gray will blend dramatically where they meet and will remain true to their colors where they don't touch. The result can be breathtaking.

Start by looking, then by seeing; after that, the sky's the limit.

## Water

As in the case of trees, there are volumes devoted to the painting of water. The kind of water you will most likely encounter on the trail will be fresh water in streams or rivers, in mountain lakes, or tumbling over and around rocks that have themselves been shaped by its action. Always the secret is to look at the shape of the body of water you are going to paint. Where is it going to go? What role will it play in your painting? What is it reflecting? Will it be the focus of the painting or will it underscore and enhance a larger composition? You must decide, and when you have, here are some ways of doing it.

Both the dry-paper and the wet-in-wet techniques will produce very liquid-looking water, but the mood of the piece can be quite different.

## Water: Dry-Paper Method

Painting water on dry paper makes use of the natural sparkle the paper itself provides when the brush skips over the dry surface. Usually water painted this way is a later addition to the painting (in the wet method the water delineates the whole composition). With that in mind, take a good look at where the water is going to go. In this case, it is going behind some rocks and sand dunes I have already painted (fig. 42). Look at the sky to help you decide what color your water will be. (Remember that the water will take its basic color from the sky above it.) I have made a blue sky, suggesting a sunny day, so my water will be blue as well, but a little bit darker in value.

*Starting point: rocks establish the theme for a water painting.*

**Fig. 42**

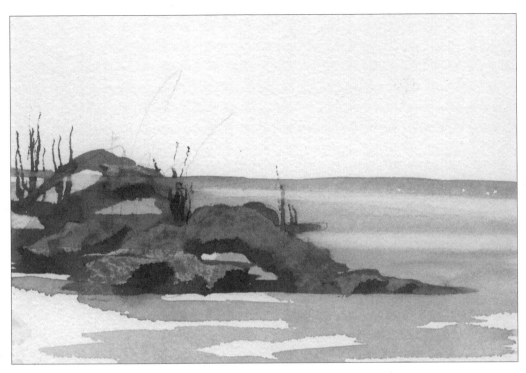

*A slosh of water across the rocks.*

**Fig. 43**

**Step 1.** Load your 1" aquarelle brush with the color you have mixed and tap off the excess on a sponge or tissue. Your brush should be full of color but not dripping wet. With long, straight horizontal strokes, quickly brush in your water area (fig. 43). If you happen to bump into a rock or a dune with your brush and develop a little overlap, blot it off with your tissue.

**Step 2.** This is a waiting step, because what is really important is that you not touch it until it has dried.

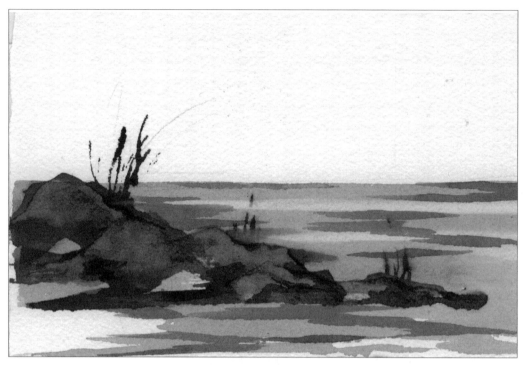

*Sliding horizontal brush strokes create ripples on the surface of the water.*     **Fig. 44**

**Step 3.** When the paint is dry, add a few dark horizontal lines with the thin edge of your brush. Hold the brush parallel to the paper and slide it along sideways into the marks you have already made that have dried. This will give you the effect of little wavelets or ripples in your water (fig. 44). Be very careful not to overdo this: less is more. If you add too many, you will cover up all the little white paper sparkles that enhance the water effect. All you will have is a flat blue patch instead of a water area.

## Water: Wet-in-Wet Technique

Sounds redundant doesn't it? Water, wet-in-wet? The fact is, the wet technique creates some beautiful watery and marshy effects quite different from those possible with the direct, dry-paper approach. (To help you understand, I used the wet technique for the marsh in the "Eastham Reverie" demonstration in the next chapter.)

**Step 1.** Wet the area that is to be your water/marsh area so it is shiny with water.

**Step 2.** With a 1" aquarelle brush loaded with a watery color, swish in some horizontal strokes, making sure you leave plenty of white areas for the color to flow into.

**Step 3.** To create island or marsh-grass areas here and there, use a darker value, such as a mossy brown/green. Hold your brush edge parallel to the bottom of the paper and touch in areas of darker color where you want your marsh masses to be. Let the darker value do the work for you.

Note in the illustration (fig. 45) that the horizontal marks alone are doing all the work of creating a sense of almost still water. See all the white spaces I left?

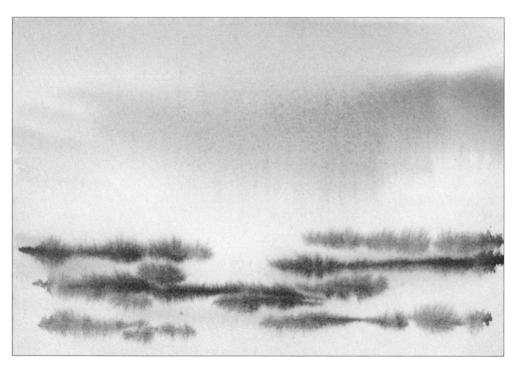

*Wet-in-wet water: horizontal strokes create a watery image.*     **Fig. 45**

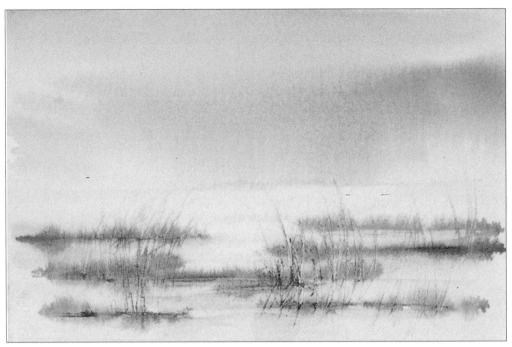

*Wet-in-wet causes paint to spread. Note darker areas in composition.*　　　　**Fig. 46**

Now see in the above illustration (fig. 46) how the horizontal marks have fuzzed outward into some of those spaces. I have also dotted in the darker masses, and while this makes them look much more "island-y," it still might not be enough to make the painting "read" correctly. In other words, the painting still does not tell enough of the story so the viewer knows what's going on.

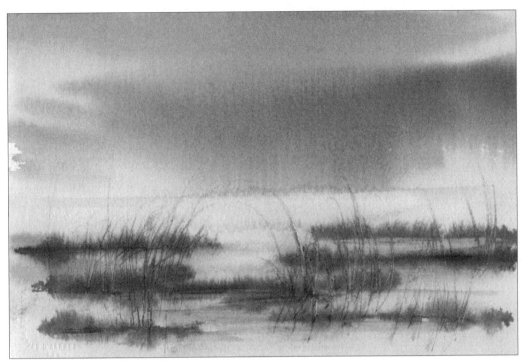

*Scratched and painted grasses create the final effect.*

**Fig. 47**

**Step 4.** To remedy this, add a few 'scratched' grasses—either with your fingernails, the corner of a credit card, or the beveled end of a flat watercolor brush. In addition, I "lifted out" (see next page) a few horizontal reflection marks from the fuzzy places below land/marsh masses (fig. 47). I'll explain these techniques in greater detail when I demonstrate "Eastham Reverie."

## Lifting Out Paint from Water Areas

This is a very handy skill. Lifting out is a way of creating reflections or light patterns in water, or lightening the value of a given area. You can lift out a little color or take it back almost to the white of your paper. Lifting out can save a painting that's gotten too dark.

You can lift color out of damp or dry paper. For damp paper, rinse your brush clean and squeeze all the excess water out of it (a flat aquarelle is easiest and best for this because you can then shape the brush into a flat skinny line). Now, with strictly horizontal lines, wipe your brush edge into the dark damp area, and lift out as many reflections as you want, taking care to wipe off the lifted paint and reshape your brush edge after every wipe on the paper. Isn't that amazing? It's a lifesaver, but don't overdo it.

Lifting color off dry paper is very similar, only the timing is different. It's particularly helpful when you have too much color in an area and you want to lighten it but not get rid of it completely.

To lift out water reflections, wet a brush with clear water but don't squeeze it out. Holding the brush sideways, with the edge parallel to the bottom of the paper, lay a line of water into the dark area that is to have a reflection. Let it sit there a moment or two, then wipe the water away horizontally with a tissue or soft rag. Wipe in the same direction as you laid it down. You should have a reasonably light streak (fig. 48). Repeat this until you have lifted out as much as you want. Be careful not to take out too much, however. Remember that you are creating a subpattern with your light lift-outs, and it needs to harmonize with the rest of the painting.

## Water Colors

I began this section with some words on the nature of water and where you might encounter it. Remember that whatever water you paint will take its basic color tone from the sky above it or from the things it is reflecting: green trees, gray rocks, a flame-orange sunset. If you don't believe me, go sit by a hidden pond at sunset and watch the drama unfold. Enjoy it alone, or bring along a friend to share the magic and celebrate the moment together.

## Wet-in-Wet Techniques for the Unexpected

Finally—a given in the wet-in-wet method of painting is the unplanned miracle or disaster. You will decide which it will be. I go into this a little

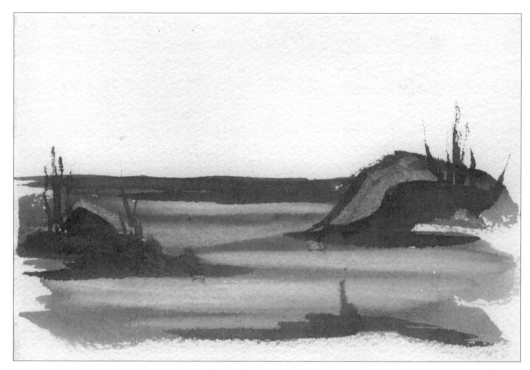

*Lifted-out areas create the illusion of reflections in the water.* **Fig. 48**

more in a later chapter, but we can look at it now so it will be familiar and won't leave you feeling overwhelmed if you have to deal with a little "gift" in the form of an out-of-control wash. Much of what I said and demonstrated in the paragraphs on marshes and reflections, really dealt with "planned accidents." Here are two techniques for unplanned accidents—underpainting and bleed back.

## Underpainting and Bleed Back

Underpainting is laying color on paper in order to tone or tint the paper or establish a pattern before beginning the actual painting. It could be planned or unplanned—a happy accident. Here's how to do it deliberately—but as you do it imagine situations where your wash has gotten the better of you and you need to turn an excess of water and color to your advantage.

Spray your paper lightly with water. Now load a brush with color (try blue) and slap it into the wet area two or three times. Really smack it in there! (Wear an apron or do it at arm's length— it splashes!) Pick the paper up and let the paint run, much as you did for skies. Lay the paper flat when you like the pattern.

Try it again on a fresh piece of paper, only this time use some vertical strokes and add an analogous color or some strokes of a darker value of the same color. You can let it run vertically so the paint drips off the bottom of the paper, or you can let it run horizontally toward either side of the paper (fig. 49). (Always leave plenty of white areas

*A random pattern of splashed color becomes a starting point for a painting.*

**Fig. 49**

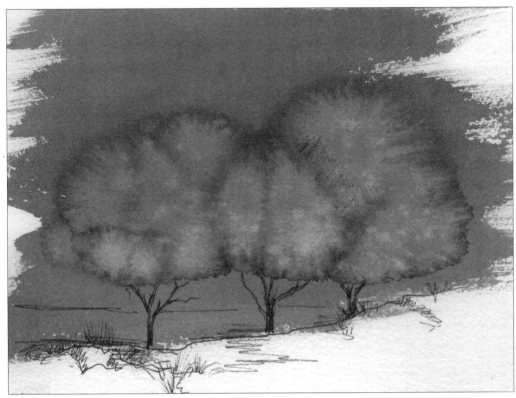

*Bleed back trees.*

**Fig. 50**

when you do this so that the paint has some place to go.) Lay the paper flat when you like the pattern. When you lay it flat, you'll notice that sometimes, when the paint and water dry, you'll find a little shape with a hard ripply edge within the big shapes. This is called a bleed back (fig. 50) and has some real creative possibilities. A bleed back can be a leaf, a flower, or (in this case) a tree in a snowstorm.

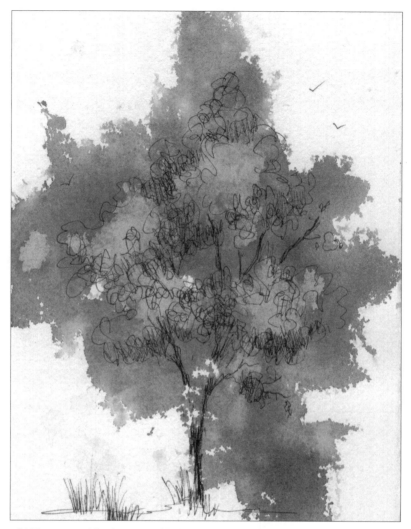

*Lifting out with tissue establishes the form; pen and ink gives detail.*

**Fig. 51**

What you do with these accidents after they dry is up to you. Consider some possibilities. One has some real floral or tree possibilities (fig. 51). Another, with its vertical lines and more geometric shapes, suggests a Southwestern Indian pueblo structure to me (fig. 52). Look at the illustrations that show the transformations. These were done with painting, pen and ink, then more painting.

*This somewhat geometric underpainting became a pueblo.*

**Fig. 52**

A lot of artists use this process called underpainting. I use it very often, sometimes because I am intimidated by the sea of white that confronts me when I look at a blank virginal sheet of expensive watercolor paper. But mostly, I like to play with these marvelous unplanned shapes and see what I can do with them. Quite often the results are even more unplanned and surprising than the starts. It's a delightful way to begin, and sometimes to end, a painting.

### Land Shapes, Hills, and Mountains

"Lift thine eyes to the mountains." Whatever is your personal source of strength, no one can deny that mountains symbolize for most of us enduring majesty and power. As such, they are subject to stereotypical mind-set images similar to those tree shapes we discussed.

Clear your head by drawing your very own hill or mountain grouping in the same way you drew trees from your memory. Draw some distant ones and some closer ones (fig. 53). Now look at them. Are they all smooth and similar, like lumpy twins or triplets? If they are, you are in good company. You need to do this first because if you don't see what's in your head actually down on paper in front of you, you won't really see the contour of a genuine mountain when it is staring you in the face.

The dry-paper method produces mountains with crisp edges. The wet technique is best used to suggest very distant mountains or a misty day.

### Mountains: Dry-Paper Method Using Layered Washes

**Step 1.** Settle down in front of a mountain range. Look at it.

**Step 2.** With your arm fully extended and finger pointed, slowly air draw the top of the mountains farthest away from you. While you are at it, notice their color and value (degree of lightness or darkness) in comparison to closer ranges. Air draw the successively closer ranges slowly—*very* slowly—always resisting the temptation to rush the process. The tendency is to think that once you've air drawn one mountain range the others are all the same. That's how stereotypical thinking and seeing happens, and that's what you don't want.

**Step 3.** Next, try drawing a blind contour: look at the subject as you draw it, not at the paper or your pencil. (Yes, you can do it!) It's an excellent exercise in seeing. Take your pencil in hand and stare at the farthest

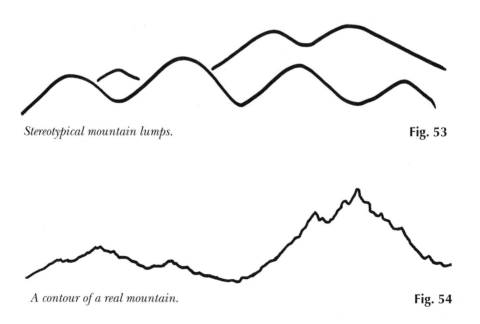

*Stereotypical mountain lumps.*  **Fig. 53**

*A contour of a real mountain.*  **Fig. 54**

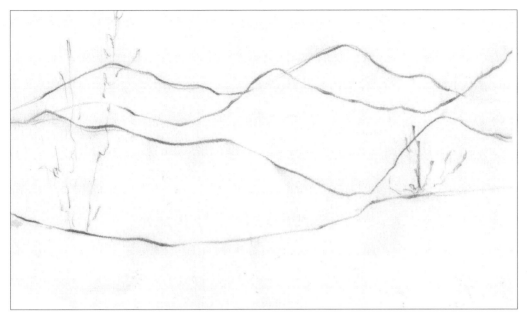

*Contour sketch of an entire mountan range.*

**Fig. 55**

mountain range. Starting way over on the left, slowly trace the top of the farthest mountain along the very top of the paper, following carefully every dip and rise. *Feel* that pattern. It's not smooth. When you're finished, look at your line (fig. 54). Surprisingly, it looks like the top of a mountain range.

Now make a contour drawing of the whole range, noting (for color and value) that the mountains farthest away from you will be the lightest in value and also the most gray (fig. 55). The closer ones are successively more intense in color. The color varies with the time of day, season, geological makeup and atmospheric conditions.

**Step 4.** If you've been really looking and seeing, this next step will be easy. Use up your dirt! Palette dirt is the stuff that collects in the corners of your palette where you don't wash it out too well. (You clean-freaks will have to mix up something neutral of a middle value.) Mix a light purple using whatever red and blue you have and quite a bit of water. Paint all the mountains with this color, the back ones and the close ones, and let them dry completely.

*Note the value differences between ranges.*                    **Fig. 56**

*Adding tree forms to closer ranges gives darker values.*       **Fig. 57**

*Done. Value shifts create depth and intensity.*     **Fig. 58**

**Step 5.** Now leave the farthest mountains alone, and paint the next-nearest mountains in a slightly darker value—the same color mixture, less water, and more blue (fig. 56). Let dry completely. Repeat this step, getting darker with each successive mountain range until you have painted them all. You can get successively greener with your color if you are painting mountains with trees on them (fig. 57). Note the color of your mountains and get more intense with that color as you come closer to the foreground (fig. 58). I'll discuss how to paint tree-covered mountains in Chapter 7.

## Mountains on Wet Paper

Mountains on wet paper will have softer edges; unless you are careful with the amount of water you are using, your mountain may run all out of control. The paper should not be too wet, just wet enough so that your strokes blur softly and don't explode. You are not painting volcanoes here, just quiet little (or big) mountains that are going to stay where we put them, almost.

**Step 1.** Draw an outline of the mountain range you plan to paint in the same way you drew it for the dry method.

**Step 2.** Wet the entire paper so that it is shiny but not running with water. Wait until it loses its shine or blot up the excess water with a tissue or sponge.

**Step 3.** With a light value of a purple-blue, paint in the farthest mountain (mountains can be lots of colors—I'm choosing purple-blue for this demonstration.

**Step 4.** With a darker value (use more blue to darken it) paint in the next-nearest range. You'll notice the edges are just a little soft, and there is a tendency for one to blur into the next. This is supposed to happen. Continue painting each nearer mountain range in the same way, getting darker and more intense with your color each time you move to a closer range, until you have filled in the page (fig. 59). Let this dry.

**Step 5.** The painting you have before you will appear to be somewhat undefined. You will need to add to it some defining objects such as trees, rocks, or people to complete the painting. What you add is your choice.

*Wet paper gives mountains a soft, gentle appearance.*

**Fig. 59**

## Torn-Paper Mountains

Here is a way of making a totally believable mountain range when you want to paint some generic mountains rather than a specific range.

Roughly tear a few strips of paper as long horizontally as the paper on which you are going to paint. Lay one of them on your paper in the upper third and trace the ragged edge to form the farthest mountain from you. Take another piece of paper, place it a little lower down than the first was, and trace its top edge. You will probably have some overlaps. This is fine because mountains do overlap. Erase the overlapping lines or they will confuse you when you paint.

Continue adding mountains in this way until you have the range you want. You can paint them in either the wet or the dry method, always keeping in mind that the mountains farthest away from you are the lightest ones, and the closer ones are more intense in color and value.

Remember this is a *trick*. It should never be a substitute for real observation—but when you need a mountain, you've got a mountain.

## Colors of Mountains

I only began to paint and draw mountains accurately after I had lived among them. The Rockies in Colorado and New Mexico were very different in size and color from the White Mountains of New Hampshire, which were my introduction to mountains.

Several years ago, I left the gentle earth tones and dune grasses of coastal New England far behind me to teach art to a wonderful group of mostly Mexican-American school teachers in Anthony, New Mexico. On my first day there, I taught my traditional first landscape, a beige and green construction of sand dunes and grasses that rolled up and down just like the gentle undulations of southeastern New England. My condescensions to the local geography and vegetation were that the dune grasses became clumpier, vaguely resembling sagebrush, and an interrupted fan stroke (actually printing a fan shape by rotating the thin edge of your brush and tapping it 180° in a fan or half-circle pattern) became a fair imitation of a yucca. But from the students in return I received flaming red sunsets and purple and blue mountains. When I questioned their powers of observation as well as their listening skills, they explained simply that they were Mexicans, and no Mexican art was art unless it was red—all red, mostly red, or soon to be red!

Humbled, I retrenched, remixed my colors and taught a sunset desert and brilliant ultramarine-blue mountain scene that was a flamboyant success. In this class the teacher was the primary learner.

The point of this is that mountains, like skies and rocks, have almost as many colors as you have on your palette. Distant mountains often look light purple, but a mountain illuminated by the setting sun can be a deep rose with splashes of orange. And a snow-capped mountain is made by leaving the paper white and painting the sky behind it whatever color you see. A dusty gray mountain will appear to be indigo (not black) when framed by a brilliant yellow morning sky. Just be sure to look.

## Generic Flowers and Nonspecific Shrubbery

### Flowers

Flower painting is the subject of many fine and beautiful books. But a brief discussion of flowers, where they occur, and how they grow is a necessary part of landscape painting. Who among us has not felt delighted in discovering a little wildflower in some unexpected place? In New England in midsummer, when a marshy lowland becomes a purple lake because of the invasion of purple loosestrife along its watery edges, who has not marveled at the stunning effect of the color?

Flowers come in a few basic shapes and combinations of these shapes. For example, daisies and cosmos are saucers; peonies are basketballs; chrysanthemums are half-basketballs; lilies are trumpets; tulips are cups; and daffodils are a combination of trumpets and saucers. For our purpose, which is landscape painting, we will not be painting their specific individual shapes. Most likely, you will be painting flowers in the mass, and using those masses as color accents in your paintings. Picture in your mind a host of golden daffodils, a field of daisies, an apple or dogwood tree in bloom, or the insistent and forbidding beauty of an overgrown rosebush on a peeling picket fence. These are my images when I think of flowers in a landscape. And how many times have I painted a field of Queen Anne's lace and black-eyed Susans? The answer is many, and each time the wonder is new. But, how to do it?

Before you add floral accents to your landscape you must, as before, see and feel the shape of those masses of flowers and plan accordingly. If your flowers are white or light colored, simply leave some white unpainted spaces where you intend to paint or indicate them later. This is great advice but I'm hardly ever so disciplined as to remember it myself. If you forget to leave space for later flowers, you have to somehow get them back into a dark foreground. This is not as difficult as it might sound.

#### Splattered Flowers

One way to get white, pink, or other light-colored flowers into a dark area is to splatter a brushload of white or light-colored paint into the dark area where you want the flowers to appear.

Do this by loading your brush with the color you want, holding it right over the place you want it, and lightly patting the stem against your index finger or your whole hand, held palm up. Little splats of paint will fall on the paper (fig. 60). From a viewing distance of about eight to ten feet, they will look like a mass of flowers.

*The secret to splatter: hold your hand and brush very close to the paper.*

**Fig. 60**

It works. Just make sure the painted surface you intend to splatter is totally dry, and practice once or twice on a separate piece of paper before splattering the piece you are working on (there are many more uses for splatter; see Special Effects below).

*Razor-blade Flowers*

Another way to add flowers to a painting is to nick the surface of a dry painting with the corner of a razor blade in flowerlike shapes and patterns. When you do this, remember the principles of design: don't overdo it, but look for repetition, harmony, balance, etc., to achieve an overall effect that adds subtly to the composition.

*Sponge flower technique.*

**Fig. 61**

### Sponge Flowers

Using the torn edge of a natural sponge, you can "print" floral-colored mass shapes with a light value into the open shapes on the paper you have left for them (fig. 61). Remember to keep wiggling and twisting the end of that sponge, so you won't be stuck with a bunch of identical "quintuplets" masquerading as a tree or a lilac bush.

If your flowering trees and bushes have a disquieting monotony you have not properly wiggled and twisted your sponge. Practice on a separate sheet of paper until you feel comfortable with the technique.

### Nonspecific Greenery and Shrubbery

Don't drop that sponge! While you are wiggling and twisting it, pick up some middle-value green color and pat a few little sponge prints in a bush pattern. Now add a few branch prints, using a flattened aquarelle brush, in a darker value, right into the pattern you have already established. Plant a few at the base of some credit-card rocks (see Special Effects below) or place them beside a little stream, and you have the beginnings of a landscape.

## Special Effects

### More on Splatter

No painting, or book for that matter, by Judy Campbell would be complete without the addition of a little splatter. It's one of my favorite techniques for adding textural interest. I mentioned its uses for flowers but there's much more. With it I can create the appearance of sand, pebbles, rocks, baby's breath in a bouquet of flowers, fallen or falling leaves in the autumn, a snowstorm, or the effects of time and weather on the side of a barn—or a human face.

Quite simply, it is achieved by tapping the stem of your wet brush against your hand above the surface to be dotted (see fig. 60, page 73).

If you want colored splatter, fill your brush with paint as well as water. If you want to flick just clear water into an area you can use your brush, a single quick shot of your spray bottle, or even your own fingers dipped in water and flicked onto your surface. Less water in your brush will make fine splatter (fig. 62), more water will make bigger splats (fig. 63). At a distance of one to two feet from the surface you'll get large, random splats—usually all

*Fine, random splatter: a little water, brush held close to the paper.*　　　　　**Fig. 62**

*Large random splatter: lots of water, brush held high above the paper.*

**Fig. 63**

over you, the table, the cat, and the wall. I have many funny splatter stories: One student ignored my rule of splattering only on the floor away from other students, and blissfully splattered red measles all over her table-mate's seascape. Another student splattered me!

Use your imagination. Experiment—alone. Practicing splatter does not cement friendships. If you are in a class with other people, go to an out-of-the-way corner, or even out in the hall. This stuff gets away from you. But, once mastered, it can be a very useful addition to your bag of painting techniques.

As I said...this stuff occasionally fights back (fig. 64).

## Uses for Splatter

I use splatter like salt or garlic: one or the other in almost everything I make. It's almost a signature with me. But just like salt or garlic, what is important is *how* it is used.

Fine splatter can make very effective sand or gravel in the foreground of a landscape. Fine white splatter looks like snow. Medium-to-coarse splatter in a tree can look like leaves, and in a dead or winter tree like the few remaining leaves autumn forgot to take.

Medium splatter over rocks gives a beautiful and very realistic texture, and medium-to-coarse splatter in a flo-ral still life gives the appearance of baby's breath or delicate little filler flowers that soften the overall feeling of the piece.

Not all splattering is done with paint. Splatter a little clear water into a damp area and you will achieve the most beautiful surprises. Sometimes, for example, a large flat area can end up being boring visually. In anticipation of that happening in a sky or other background area, flick a little water into the area before it has dried and then watch the magic. You won't confuse the painting with too many colors but you will achieve a little visual excitement without creating a second focus.

**Fig. 64**

**Fig. 65**

**Fig. 66**

**Fig. 67**

**Fig. 68**

## The People Stroke

What are people doing cluttering up our beautiful landscapes, you well may ask! The same thing you are doing: enjoying it! People strokes are literally a dot and a dash. A dot for the head and a dash or two for the rest of the body (figs. 65–68).

You can do this most easily with your #10 or #12 round brush. Push down to make the dot, and push down and flick down to make the dash. Angle the dashes however you need to and add what's necessary—and there you have it.

## Credit-Card Rocks

An old credit card works very effectively to scrape out the textural appearance of rocks, tree trunks, barns, and anything else that needs scraping. (It works very well on frosty windshields as well.)

Hold the card at about a 40°–50° angle to the paper and push the paint to one side, using a firm quick stroke. Like the splatter this will take some practice, but it's really quite effective.

Figure 69 shows the proper way to hold the card. Put your thumb on the corner of the side facing you and squeeze it just a little. Lay the card on the paper so that a whole inch or two of the long side is flat on the paper and then push or scrape the paint aside. Don't scrape so hard that you scratch the paper; use only enough pressure to move the paint aside. The results will be similar to the marsh "rocks" in figure 70.

Hints: If your paper is too wet or too absorbent, the paint will sink in at once and you won't have a rocky-looking surface. Also, if you are using really poor-quality paper it won't work well. This technique takes lots of practice but can be a real help when you need a rock or a mountainside in a hurry.

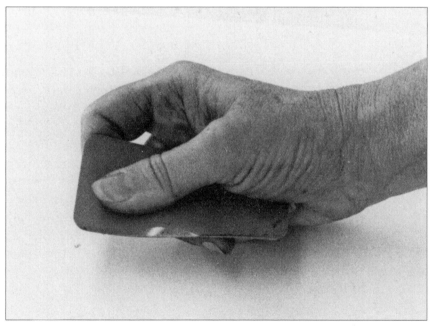

*Making rock textures with a credit card. Remember, this takes lots of practice. Don't get frustrated.*

**Fig. 69**

*Finished credit card rocks.*

**Fig. 70**

The most common errors using this technique are two. One is using only the corner of the card instead of the long edge, which will give you dark streaks. The other is that once you learn the technique, you might forget to vary the size and shape of your "rocks" and get rock-clones all over your painting.

Don't get frustrated if it doesn't work the first time. It takes lots of practice to get it right. And remember, like any good cliché it can be overused.

In the demonstration chapters I will incorporate credit-card rocks, sponge bushes, splatter and possibly some scraped flowers, and even a tree or two. Sounds like a "blue plate special" doesn't it? Whatever it is, and whatever you choose to call it, once you use these techniques, the result will be a real painting you will have done all by yourself.

## Mirror Work

Finally, the old mirror trick. It isn't actually a trick at all, but a way of looking at your work from a distance and seeing it with a fresh eye. To evaluate your picture, stand about four or five feet away from a mirror with your painting in front of you, facing the mirror. Look at your work in the mirror. Its image will now be about eight to ten feet away—the optimal viewing distance. It will be a reversed image. A reversed image will show you whether the various components of your painting are working in a way that just looking at it from across the room cannot do. What do you think? Could you improve it a little? Or should you leave it alone, to mature in your imagination until the next time you take up your brush?

## Happy Accidents

One of the most magical qualities of watercolor is its gift of the unexpected. Watercolor is predictably unpredictable; the trick is not to be dismayed when it happens but to follow its lead and see where you end up.

I have produced some really beautiful paintings I thought I had ruined through accident. A piece that I fished out of the stream I was painting was vastly improved by its bath. It had started out too dark, and I didn't realize it until I saw it lighter. And a brush dropped into a landscape is not a disaster, it is a future bush! Don't be crushed by the accident, be creative with it. Always look for positive possibilities.

# Section Two

# Using the Tools— Demonstrations

Chapter 5

# Demonstration I: Marsh Grasses and Water Using the Wet-in-Wet Technique

*"Eastham Reverie"*

---

**Materials**

| | |
|---|---|
| Paper | d'Arches 140 cold pressed |
| Brushes | 1″ aquarelle brush |
| | #3 rigger |
| Colors | Antwerp blue |
| | yellow ochre |
| | ultramarine blue |
| | olive green |
| | burnt sienna |
| Other | Fingernails, the end of the aquarelle brush, or the corner of a credit card |

---

After all the preparation of the last four chapters, you are finally ready to paint a real picture. I will start the demonstration chapters with a wet-in-wet painting of a salt marsh in Eastham, Massachusetts, on Cape Cod.

I am using the wet technique for the first painting because it makes use of one of the things that watercolor does very well—run colors together. That is the intended lesson, so don't be dismayed when it happens. It's supposed to.

It would be best for you to follow the demonstration chapters step-by-step right along with the book. In this case, it's acceptable to copy another person's work. For one thing, it alleviates the worry about which colors to

choose and how to mix them. More importantly, if you follow the directions you will come out with a painting and a learning experience at the same time.

This particular painting has an amusing history. Anyone who has been to Cape Cod, the beaches off North Carolina, or the tide flats of southern Maine has seen this place and this painting. In reality it is in Eastham, Massachusetts, on Cape Cod, a little past First Encounter Beach and before Rock Harbor in Orleans. It's a very private place and usually only the locals go there. Because it is on the bay side of the Cape, the water is only deep enough for real swimming for a few hours a day. But the tide flat offers hours of solitude, sand-castle construction, and the fun of wading in pools warmed by the sun in search of fiddler and hermit crabs. It is a safe place for young children and a quiet haven for their mothers and fathers. I have painted it more than once, and on this particular day I headed off, delighted with the thought of the place and the hours of solitary contemplation the art of painting allows. I found my spot, a little east of the last time I'd been there and not as far north as I would be the next time. The tide was half out and the view before me was of the marsh in early fall. The green marsh grass was beginning to change to gold. It had reached its fullest height. The midafternoon sun gave me shadows that would obligingly lengthen as the afternoon unfolded, and I was marvelously content. After a period of studying the landscape before me and getting the feel and mood and peace of the place, I began to work. I started with only the most fragmentary sketch, because what I had in mind was to paint a response to what I saw, rather than make a cameralike reproduction or an illustration.

A single lightly drawn line slightly above the middle of the paper established where my sky and water line would be and also where the sky would be reflected in the remaining pools of water left by the constantly shifting levels of the tide. Once my basic layout was complete, I began to paint. Curiously, as I worked the tide pool, patches of blue I had counted on as part of my well-constructed design were not as I first thought they were. I had missed a few but still they seemed to fit into the overall design, so I swished them in and went back to fiddling with the marsh grasses in the foreground. When I looked up to check the light and the lengthening shadows, I spotted a few more tide pools I'd missed. Rats, I thought, my eyesight must be going, or I was really being careless. I swished in the stragglers and went back to my grasses only to discover that I was rapidly becoming part of my own foreground. The tide was coming in, not going out, and the tide pools I thought I had missed were in fact multiplying before my eyes and, embarrassingly, under my feet and seat! I was surrounded by shallow water, and had to wade a hasty ankle-deep retreat to the car, a towel, and dry socks and shoes! So much for concentration.

I started this painting with a single pencil line, a little paint, and some water, and let the painting unfold itself. A more detailed pencil sketch would have been just as effective, but I used only a single horizon line to show how the wet-in-wet technique can almost paint itself if you let it and if you can stop yourself from overworking it. No small task! I started by show-

ing you the finished painting, so you'll know where we are heading. Now I'll back up and show you how it developed. (Thanks to photographer and friend Pat, who took the photographs and also kept me from going too far, too fast. Once I am painting I get carried away. Pat hollered "Stop" at appropriate times to get the step-by-step sequence of photos you see here.)

Please don't try to make an exact duplicate. You'll only frustrate yourself. Just have a go at it, and then another one. You will be pleasantly surprised at what flows from your hand and your imagination.

It will be much easier if you have everything ready before you start. I have listed the paint colors and brush sizes I used. The size of the paper is not too important, but try to keep the proportion the same. What you want is a long horizontal: mine is 9-1/2" x 18-1/2". You might try 7" x 15". Too small a piece will cramp you and too large a piece will intimidate a beginner.

This painting demonstrates the wet-in-wet technique. It's user-friendly because the paint is supposed to bleed, slide around, and, in general, do what it wants to. The secret is to let it happen and not worry too much about where it goes. If you lay it down in the right direction and in the proper area, gravity, levity, humidity and the power of prayer will do the rest.

*Start by reading all of the instructions all the way to the end before you pick up that brush.* Practicing the scratched grasses and splatter techniques a little bit will also help.

**Step 1.** Start your painting by thoroughly wetting your paper so the entire surface is shiny with water. If your paper is curling up on you, give the back side of your paper a light

squirt or two with your spray bottle. This will help flatten it. (I don't like to tape my paper to a board or to the table because it inhibits the natural expansion of the paper and makes it ripple and worse, it inhibits me, should I want to pick up the paper and let the color run in a specific direction.)

Mix up a light value of the Antwerp blue: take a little water and some of the paint on your brush and swirl it around on your portable palette or in your mixing area until you have a color you like. (Note the amount of paint you pick up for future reference; note also that the paint will be further diluted by the water on the paper and will thus have a lighter value—so mix up a color that appears a little darker than you actually want it.) Now take a deep breath and just slop some of that paint onto the wet paper in long, smooth horizontal lines: sky lines at the top, and lower down some water/tide-pool/marsh lines (fig. 71). Leave lots of white wet paper showing. That is for the grass to grow in and for more tide pools if you need them!

**Step 2.** Quickly now, while your paper is still shiny wet, rinse the blue off your brush and pick up some yellow ochre. Swish it along with some water in a clean mixing area on your palette. Add a little olive green or burnt sienna if it looks too yellow—mine did, so I softened it with a very small "whisker" of olive green.

Load up your brush with this color and slosh it into the background and foreground with long, broken horizontal strokes that will become patches of marsh grass as soon as they start to spread. Stay out of your sky. It should be doing its own developing. As the blue strokes spread into the white

*Step 1: First strokes on wet paper. Broadly delineate your composition.*  **Fig. 71**

*Step 3: Adding more color to your basic composition increases the sense of depth.*  **Fig. 72**

areas, pick up more yellow ochre and a good glob of olive green this time, and swish it so the colors are well mixed. Touch this darker value into the foreground area and out from the foreground edges so the edges look a little darker and the lighter areas are nearer to the middle.

**Step 3.** Repeat this procedure, only this time pick up your yellow ochre, add some burnt sienna to your mixture, and leave out the green. Add enough burnt sienna so that your color is really rusty gold/brown. Work this color into your painting, particularly in the closest foreground, and touch it into the base of some of your grass clumps so that it looks like reflections (fig. 72).

**Step 4.** You'll notice some dark splatter in the very foreground. I splattered a dark value to suggest the fluffy vegetation that grows so tall and gracefully in a marsh. Complete the painting by scratching some long wavy grasses into that foreground you have just splattered, and carry some of that dark color along with your fingernail (or credit card) to make more grasses.

**Step 5.** The near-final touches are made down in the foreground by adding some wispy little grasses with the skinny rigger brush, the very tiniest corner of your 1" aquarelle, or the very tip of your round brush.

**Step 6.** Take a look at it. If you need more, it's okay to splatter your painting. Don't worry if your painting has dried by now—you can still do it.

*Note:* Don't ever use black in a landscape! Make your darks by mixing the darkest colors of that particular painting.

Here are some finishing touches: Notice in the painting (fig. 73) how the scratched grasses and the painted grasses are of different lengths, and how they seem to tumble over one another. Long wavy grasses do that in real life so they should also do it in your painting. Also note the addition of some little birds in the upper left (I make them by printing wide Vs with the flat edge of my aquarelle). They look nice, especially because they are hiding some unplanned splatter.

There now! You should have a real painting in front of you. It is probably lighter or darker than mine. It probably has more or fewer tide pools, and your feet probably aren't wet unless you spilled your water on them. Look at your painting with a loving, not a critical eye. It is the first of many. Don't try to make all your corrections in one place or at one time, but do read these helpful hints, and keep them in mind for the next painting.

1. Look at your painting from about eight to ten feet away. Paintings are not meant to be viewed at arm's length. There, doesn't it look better already? And tomorrow morning you'll like it even more.

2. If your colors seem to be pale and washed out, next time use more paint and less water.

3. Conversely, if the whole thing is too dark and thick with paint, use less paint and more water.

4. To keep your painting looking fresh, don't overwork it. In other words, don't keep going back into it to get something just the way you think you want it. By the time you finish the painting you will have forgotten what you thought

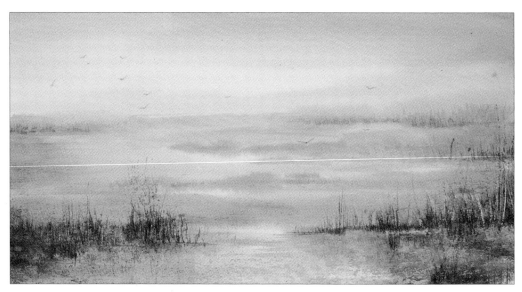

*Step 6: The finishing touches are the most fun and really pull the painting together.*  **Fig. 73**

you wanted, and the result could well be a delightful surprise!

5. Finally, when you try this lesson again (and I do recommend that you repeat it several times), try using totally different colors. Try, for example, using just blue and purple, or one of my favorite blends, ultramarine blue and burnt sienna. Or for a real shocker try cadmium orange, if you have it, and warm sepia! Dramatic, very dramatic! For even more drama, try alizarin crimson and thalo or Antwerp blue. The sky's the limit (or maybe the wallet is) but try out whatever colors you have in the spirit of freedom that

a beautiful landscape suggests. Anyone who has watched a marsh or a mountain through the hours of a day and the seasons of the year knows that any color and any mood can be "natural."

You are on your way. The next painting will be a little more controlled and less reliant on the happy accident and free blends of the wet-in-wet process, but it will build on the skills you have gained here and add to them in a logical and practical way. You are filling your artistic tool bag with skills and knowledge that will last you for a lifetime. And the best part is, there will always be room for more.

# Chapter 6

# Demonstration II: Trees, Rocks, and Mountains Using the Dry-Paper Method

*"Morning Walk, Pinkham Notch"*

## Materials

| | |
|---|---|
| Paper | 11" x 15" (quarter sheet) d'Arches 140 cold pressed |
| Brushes | 1″ aquarelle brush |
| | #12 round |
| | #3 striper or rigger |
| Colors | Antwerp blue |
| | ultramarine blue |
| | yellow ochre |

| | |
|---|---|
| Winsor violet | olive green |
| alizarin crimson | Indian yellow |
| burnt sienna | opera |

This painting proved to be the most challenging of the demonstration paintings. It took four tries for me to get an image that I liked. At the same time, it was a good lesson. The reason it became so difficult was that I kept getting too involved with the painting and the unnecessary, minute details of the scene, and I complicated myself right out of business. I was not following my own "less is more" principle. I was trying to say "treemountainskyforeground background" instead of "trees against a distant mountain."

The place is a lookout on the way to Glen Ellis Falls in New Hampshire, very near the Pinkham Notch Visitor Center. The path that leads to the waterfall follows the contour of the mountain and brings the delighted first-timer down into the thundering grotto at the base of the drop.

I was on a post-breakfast walk with a student in a class I was teaching. We stopped at just about every turn to snap a photo or make a quick sketch for later work. I took the picture from which I made this painting that morning.

As I said earlier, the trouble I had with the painting is commonplace for most beginning painters and some experienced ones too: I simply tried to say too much. I got just as involved with the sky and the mountains in the background as I did with the trees and rock outcroppings in the foreground.

Another problem I encountered was that, typical of a midsummer painting or photograph, there was almost too much dark-to-light contrast because of the intense sunlight, at a time of year when the only colors one really sees are green, green, and green. I helped that along in my final washes by touching in some alizarin crimson and opera pink in some of the shadow areas, which made for greater depth and a visual curiosity that really took the painting out of the realm of mere visual record and made it a visual statement. It wasn't easy. But, as I relate its development to you in the step by step sequence that led to its completion, I can simplify it so that you can learn from my previous mistakes.

Once you set out all your materials, you are ready to begin.

**Step 1.** You really need to start this painting with a drawing (fig. 74). You need to know exactly where those trees are going to be located, just how much of the background you want to be mountain and how much you want to be sky. Also, note that in this particular painting two kinds of trees are in the foreground. There are evergreens on the left and deciduous trees on the right. You learned how to paint both kinds in the earlier chapter on specific techniques, and if you practiced them then they should pose no problem now.

Notice also that the drawing is light and sketchy. It is not a finished drawing, and I will probably erase the pencil marks left in the white areas when I complete the painting. I say "probably" because sometimes I leave them in if they look like part of the painting. There is no hard-and-fast rule about that.

[It is not hard to erase the pencil marks once a painting is completed as long as you wait until the paper is completely dry and you use a soft kneaded eraser or a gum eraser. If you have made your sketch very dark not all the marks will come off, but they will certainly fade out enough that they will not pose a problem.]

Once the drawing is complete and you've checked your basic design, you are ready to begin using your paint.

**Step 2.** I started by mixing a light value of Antwerp blue and ultramarine blue on my palette and filling in the dry sky area. I didn't try to cover it evenly; I deliberately kept it uneven and blotchy but all of it in a light value. While it was still wet, I added the distant

*Step 1: the drawing.*                    **Fig. 74**

mountain. I tried to keep this even more blotchy by not mixing my paint too much on my palette and actually picking up the two separate colors on my brush, rather than a perfectly homogenized blend. This gives a distant feeling of texture when painting in the mountain area. To that deeper sky color of Antwerp blue and ultramarine blue I added a very little bit of Winsor violet up near the top of the mountain area. Then I worked my way into the base of the mountain area using some light values of olive green (fig. 75). Have you noticed that distant mountains often look purplish and closer ones look more bluish? It's only when you are right up against them or in their majestic midst that they look really green.)

Anyway, by keeping my distant mountain color and value light and indistinct I achieved the feeling of distance and at the same time showed a solid object. It became a setting for my main theme: the foreground trees and their exquisite contrast. The story I try to tell in this painting is of trees—evergreen and deciduous, one in shadow and one in sunlight.

**Step 3.** To prepare my tree areas I washed in a very little background color where I planned to place them. I used some yellow to fill in that area on the right where the sunlit tree would later go, so the areas I left empty of leaf shapes would look bright and sunny when I painted in the darker bunches of leaves. It is particularly important for the sunlit tree on the right-hand side of the picture to have virtually clean paper underneath it, so that the yellow—by nature not a very strong color with almost no covering power—could be used to its maximum effect.

**Step 4.** In this next step, you can see the bright yellow tree area and the yellow highlights on the rocks where the sunlight is falling upon them (fig. 76). You'll note that I've left plenty of air holes (white spaces) and the whole thing looks like I did it with a sponge rather than a brush. I used a brush, blobbing and plopping in the color with a dabbing, jabbing motion rather than a stroking or painting action. If you *think* "dappled light" as you *paint* "dappled light," your brush ought to follow your thought. There's also plenty of room for other colors to be added into that yellow blobby area.

**Step 5.** The addition of the three towering pines on the left and the swishes of medium blue in the foreground will make a dramatic visual statement. Don't hesitate or fuss here, just swing

*Step 2: first layers of color delineate the pattern.*     **Fig. 75**

*Step 4: Note the additions of yellow in the spaces left for them.*

**Fig. 76**

in those trees with fast quick strokes. You can use your #12 round brush or your flat aquarelle. The result will be a strong, dark, linear tree pattern against the mountain shape in the background—the main theme of the painting (fig. 77). The rest is "frosting."

**Step 6.** I have told the story now. What remains is adjusting colors and values, adding details, and being careful not to get carried away, to overstate the obvious and thereby eliminate the impact.

To add detail, I flicked a few fingers full of water into the blue in the lower left foreground rock area while the paint was still wet. This created some visual texture where it had been too flat. I wanted to *suggest* rock texture, not hit you over the head with it. If I made it too strong and too detailed it would have pulled your eye away from the trees, which is what I really want you to be focusing on. But as I looked at the rocks, even with the texture added, I saw they needed more visual weight. Rocks need to be massive and substantial enough to support a stand of trees without drawing your attention away from those trees. The solution is in the next step.

**Step 7.** When I added the darker values to the sunny side of the tree I

added some of those same darker values to my rocks in the foreground, with blobs of paint in the trees for darker shadows and some swishes of paint in the rock area. When those dried, I enhanced each area with a little dark splatter smacked from a moderately wet brush, held no more than two inches from the paper (fig. 78). The splatter added still more texture and contributed to the atmospheric and unordered quality of the painting. (By "unordered," I mean trees should not look starched and ironed and tight. They are gently moving, changing things that deserve this quality in their representation.)

**Step 8.** I thought this painting was done once, and the last illustration shows you that first state of doneness. But as I looked at it again, I felt overwhelmed by its coolness. I added some touches of alizarin crimson and my favorite eyeball popper, Holbein's marvelous fuchsia color, opera, a pink that defies gravity. I also added some yellow-ochre splatter into the rocky foreground area as well as some skinny directional lines. Some of these were done with a really fine (#3 or #4), long bristled rigger or striper.

In addition to these I added more random skinny lines and drips that straggled into the white area in the

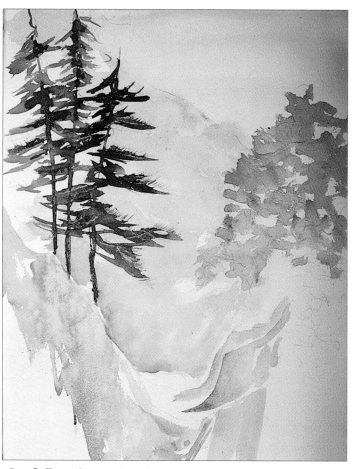

*Step 5: Enter the towering pines.*  **Fig. 77**

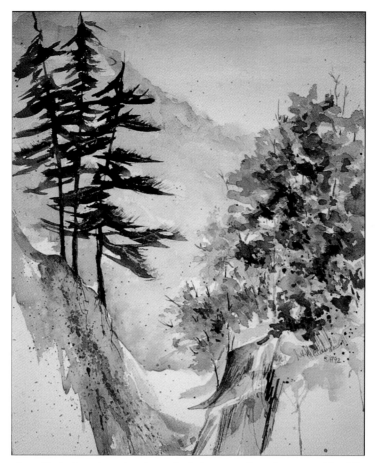

*Step 7: dark values in the rocks help to anchor the composition.*

**Fig. 78**

foreground. These were achieved by blowing into small puddles of wet paint in the direction I wanted the drips to go. If you try this, hold your painting two or three inches from your face, and blow hard at the puddles of paint in the direction you want it to drip. Do it in short explosive puffs— like blowing out a candle. The results are random, delightfully squiggly drips that add to the untamed, irregular quality we so love in nature (fig. 79). They also suggest to the more literal-minded those wonderful patterns created by exposed tree roots when they cling tenuously to the mountainside after a rock fall. (The visual impact of exposed tree roots is particularly attractive to me, and I have done entire paintings of just the abstract patterns made by these tangled and twisted—and ordinarily hidden—miracles of nature.)

I also added little wisps of trunks and branches to the sunny trees and "piney" wisps to the shadow trees using my skinny rigger brush. This detail adds "readability" to the piece. The wisps say "tree" a little more clearly than if I had left them out. They also add a nice vertical repeat, in a softer key, of the verticals on the left. Speaking of repetition, note the repetition of the yellow ochre in a very light value

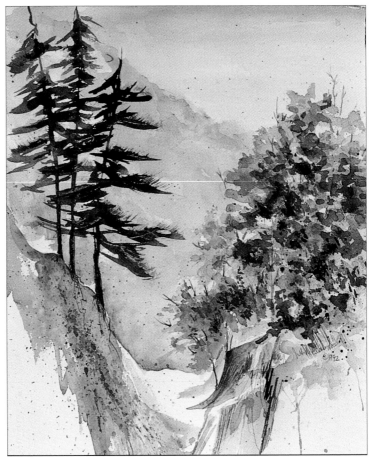

*Step 8: bits of warm color and little drips and wisps complete the painting.*

**Fig. 79**

along the top of the mountain area. I like to repeat my colors around a painting when I can. It adds to the unity and harmony of the piece.

My painting is done, and I hope you will try one like it. Remember, it took me four tries to get this one and I'm not showing you the first three! So if your first one, two, or six are not exactly as you think they should be, pause for a moment, look at it (or them) and find in each one something you like. There will be something, and that will be one more skill you have learned, one more technique you have mastered. Look for the good in what you do. It's there.

Chapter 7

# Demonstration III: Mountain Range—A Value Lesson Using the Direct Painting on Dry-Paper Approach

*Morning Light, Montana*

---

**Materials**

| | |
|---|---|
| Paper | 9"x15" d'Arches 140 cold pressed |
| Brushes | 1" aquarelle |
| | #3 or #4 striper or rigger |
| Colors | Antwerp blue or ultramarine blue |
| | Indian yellow or yellow ochre |
| | olive green or a mixed green |
| | sepia or a warm dark brown |
| | alizarin crimson |
| Other | An old credit card |

---

If you have ever walked or driven through mountains you know that when you can see several ranges receding into the distance, the faraway ones seem much fainter in color than the closer ones. This changes according to the atmospheric conditions. On the day after a storm, when the air seems to have been swept clean, you can see very far to the most distant mountains. On clear dry days, they will look quite blue. On humid days, or dusty days if you live in the southwest, you can see much less far away, and what you can see is far less intense in color. This is referred to as aerial perspective, or the perspective of color and space. Linear perspective refers to the way parallel lines appear to converge at the horizon or eye level to sug-

gest depth or distance in painting. Artists use both techniques to make things in their paintings look closer or farther away according to the needs of the composition.

This chapter demonstrates how to paint a mountain range that has both depth and realistic configuration. It also includes a little bit of a trick—using torn paper to outline mountain shapes. Refer to the earlier discussion of this technique in the Mountains section of Chapter 4.

If you were out on the trail, you should air draw the mountains a couple of times so you get the feel of them. If you don't do this prior to drawing them for your painting, you will draw those stereotypical "muffin" mountains that live in your brain near the triangle and broccoli trees.

Once you have done the air drawing and you really have the feel of mountains in your arm and hand and brain, you will find this little trick both effective and helpful.

I have constructed this painting in a more horizontal format than the others in this book. You will notice also that it is the painting used on the cover. Here is how I did it.

Start with a 9"x 15" piece of paper, and two pieces of torn paper, also 15" in length.

*Step 1: two torn strips of paper for the tops of the mountain ranges.*          **Fig. 80**

**Step 1.** Hold one of the long edges of the torn paper near the top of the watercolor paper and trace it to draw the first and farthest away of the distant mountain ranges (fig. 80). Now take the other piece of paper, move it down a little bit so it overlaps the first line here and there, and trace its top edge again, and you have the top of the second, or next-nearest range. So you don't confuse yourself with a tangle of lines, erase the pencil overlaps. By doing that you won't be faced with a confusing tangle of lines when you start to paint. Keep adding lines in this manner until you have created the

mountain range you want to paint. Check again, before you start. Have you erased all the overlaps? Are you clear which mountain is which? Now you are ready to start painting .

Leave the sky alone for now. In other paintings I might have you paint the sky first. This time I want you to wait so you can learn to put a sky in later. It is a handy skill and not a difficult one.

**Step 2.** Start by mixing a very light value of purple. I got this color by mixing a tiny bit of alizarin crimson with a little bit of ultramarine blue or Antwerp blue with a good splat of water. When you like your color, paint in the farthest mountain range, trying to stay within the lines you have drawn. If your brush skips here or there, don't fill in the white spots. They will look like distant rocks or snow caps, depending on what you are intending to convey in the rest of the painting. Add a little blue to that purple mixture, but don't add any more water.

Now you have a darker color and value with which to paint your next-nearest mountain. Again, if your brush skips and you have a little white spot here or there, just leave it; you will like it later.

When that mountain space is filled in, go on to mix a still darker value by adding a little more of your blue and also some green (fig. 81). I used olive green, but if you don't have that you can make a really good green by mixing blue and yellow together and adding them to your mountain color.

**Step 3.** Now here's a surprise: the next-to-closest mountain is actually going to be lighter than the one behind it, but it will look closer. This time, start with a new color completely. Take a clear clean yellow, such as yellow ochre or Indian yellow. I used Indian yellow. Mix a little green into your yellow and smear the mixture into your second-nearest mountain. While it is wet, add a little of your blue and let it fuzz out a bit. This is going to look like trees you can see on a near mountain, but trees

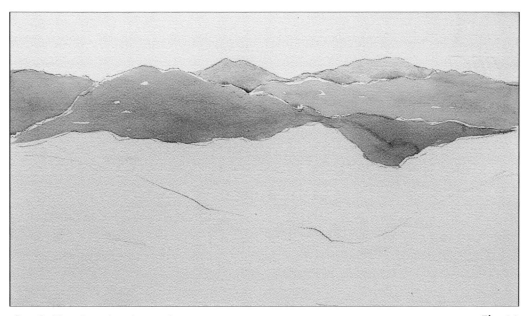

*Step 2: Note the value changes between ranges.*

**Fig. 81**

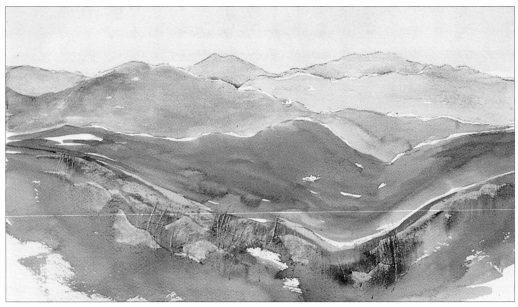

*Step 3: the addition of the foreground brings the painting to life.* **Fig. 82**

that just look like solid shapes, without individual branches or leaves.

It's probably a good time to let this air dry for a while. If you are near a hair dryer, use that.

Letting the painting dry will accomplish two things. It will keep the colors clear and clean because you have let the first layer of color dry. It will also provide you with time to look at your painting and consider which step to take next. I headed for the sky.

With a dry painting in front of you, mix up a sky color. I used a light value of the blue I used in the mountains. You might choose a gray sky, or sunrise or sunset colors, or follow my lead. I made a pale blue tint, using quite a bit of water to make the color, and then brushed it quickly into the sky area. I actually bumped into several of the mountain tops, but I blotted out any overlaps of color with the tissue I always have in one of my hands. With that same tissue, I decided to make a few wispy clouds in the sky—not too many clouds or too much color in the

sky, because I wanted my mountains to be the main focus of interest in the picture. A bright, busy sky would divert that focus.

With the sky in place, I concentrated my energy and my paint on the foreground. I planned to paint the nearest land mass in bright yellows and greens to suggest sunlight and summer warmth. I loaded my brush with lots of thick yellow and green paint at the same time. I moved that paint into the foreground area, using strokes of the brush to follow the contour of the land mass I had drawn in earlier. The two colors came off my brush separately, giving a very grassy and realistic look to my foreground. I left some white spots here and there, especially down near the bottom (fig. 82).

While this area was still wet, I added some blue streaks and some very little brown ones, just as I did in the last mountain range I painted. When the blue and brown marks began to lose their shine, I made some credit-card rock shapes in the way that

was demonstrated in Chapter 4. (If you have forgotten how to make them, it would be wise to practice a few before trying them on your paper).

You will notice as you are making your rocks that dark pools of paint are accumulating where you have scraped the color aside. You can turn these pools into clumps of grasses by waiting a moment or two, or until they start to dry a little. Then take the wispy ends of a squashed brush and flick some of the thickened paint upward, much as you would if you were actually drawing them with a pencil.

Wait again until all of this is dry. You can assist this by putting it in the sun or using a hair dryer. Whatever you do, wait until it is truly dry before going on, because the last few strokes will be the ones to make your painting sing. If you are impatient, it might just squawk.

When it is dry, you can finish it up by using your striper or rigger brush to whisk lovely little grassy areas in and around your rocks. Use a dark value of blue and green mixed.

**Step 4.** Now is also the time to darken in your second-nearest mountain a bit by adding a few more tree shapes. Do this by picking up a little of your dark blue-green color and just tapping in clumps of shapes rather than specific trees (fig. 83). The only really specific shapes will appear on the closest land mass, nowhere else. This is another use of aerial perspective I mentioned earlier: things close to the viewer are in sharp detail, things farther away appear less distinct to the eye.

**Step 5.** The bare tree and a little well-aimed splatter in the foreground are the last additions to this painting. You may decide to complete the painting with a pine tree or a hiker, or you may decide it looks good the way it is and leave it alone. The choice is yours. I completed this painting using the

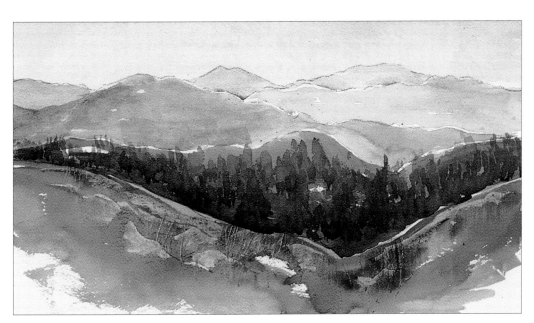

*Step 4: tapped-in trees, middle range.*

**Fig. 83**

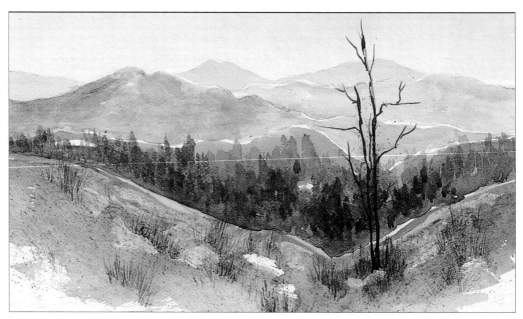

*Step 5: fine-tuning with splatter (carefully applied!)*

**Fig. 84**

same brush I used for the grasses and a dark value of a mixture of blue, brown, and a touch of green. If you use a tree to complete your picture, use the same colors you have used throughout the rest of the picture. Now is not the time for the addition of new colors. It will look out of place.

To add the finishing touches in the form of a little brush splatter, take a little of the tree color and lighten it by thinning it with some water. Load your brush and tap off the excess on your sponge. Remember that it is always wise to practice off to the side before attacking the real thing (fig. 84).

**Step 6.** Now, stand back and admire it. While you are at it check the values. That, after all, was part of the point of this lesson. Do your background mountains seem to recede? Is your foreground really up front? If so, you

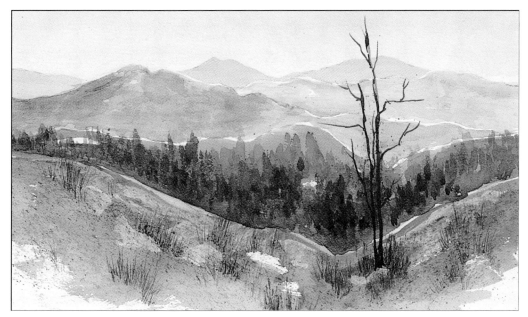

*Step 6: final fine-tuning.*                    **Fig. 85**

are finished. If the values are not quite right and a mountain is sticking out where it shouldn't, you can lighten or darken it. To lighten an area, wash it over with clear water, using only one or two strokes. Wait a moment for the paint to loosen and blot up the water with your tissue. Repeat this until the area is as light as you need it to be.

To darken an area that seems too light, wash the space over with a slightly darker value of its original color.

That should do it. If it doesn't, repeat the process until it does.

You are finished (fig. 85). See how important the concept of value is in this piece? It is important in everything you paint, but this lesson shows it exceptionally clearly.

You might want to repeat this lesson in winter or fall colors, or in sunrise or sunset colors, but keep in mind that the value and intensity of a color tell your story more than the actual color itself.

# Demonstration IV: Sponge Trees, Credit-Card Rocks, Fall Foliage, and Scratched-out Flowers on Dry Paper

*"Glorious Vermont"*

**Materials**

| | |
|---|---|
| Paper | 7-1/2" x 11" (vertical) d'Arches 140 cold pressed |
| Brush | 1" aquarelle |
| Colors | Antwerp blue |
| | Indian yellow |
| | warm sepia |
| | alizarin crimson |
| | cadmium orange (if you have it, or mix alizarin, crimson and Indian yellow together) |
| Other | A piece of natural sponge |
| | An old credit card |

Anyone who has experienced the glory of a New England fall will appreciate knowing how to paint it. For this demonstration I painted a maple, but if your fall takes place in the Rocky Mountains, give this tree a white trunk and golden yellow leaves and you will have an aspen all decked out for autumn.

**Step 1:** Observe and frame the space you want to paint. By that I mean limit it to one tree and a few rocks rather

*Step 1: light pencil sketch of composition.*     **Fig. 85**

than a whole mountain range of fall colors. That can be an interesting exercise, but we will learn more by painting a more focused piece this time.

Once you have decided what you will paint, draw your composition lightly on your paper with a pencil (fig. 85).

**Step 2:** On dry paper, with a light value of Antwerp blue, whisk your sky into the sky area with quick horizontal strokes. Remember to leave some white spaces in the sky for clouds. If you forget, pull some white spaces back out by using a crumpled tissue and blotting

up some cloud shapes.

While the sky is still damp, clean your brush and pick up some green that you have mixed by combining Antwerp blue, Indian yellow, and a whisker of sepia, and, using long, wide diagonal strokes, paint in the mountainside. When you do this, leave the area where the rocks and the tree trunk are going to go completely dry and without paint. Now clean your brush and, while the mountainside is still wet, mix a rock color using Antwerp blue and sepia to produce a gray. Wash that gray color over the

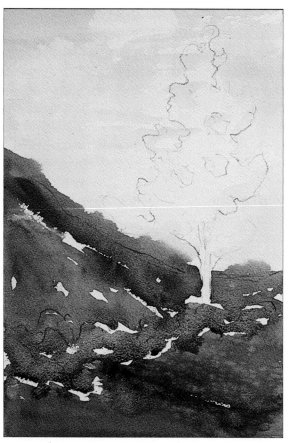

*Step 2: addition of sky, mountainside,*          **Fig. 86**
*and area for rocks.*

rock area (fig. 86). Leave the tree-trunk area dry for the moment; we will come back to that later when the foreground has dried completely.

**Step 3.** Wait for a minute or two until the paint starts to set up and loses its shine. If you wait too long you won't be able to scratch out any rocks, and if you scrape too quickly your rocks will just be muddy puddles with no definition. Timing is the hard part here.

Scratch out a few small rock clusters using your old credit card. Start by going down the background area, fol-lowing the contour of the hillside. Following the contour is important here because if you don't, your rocks will look like they are floating in opposition to the land. They won't look like they belong.

Once you have some background rocks in place, do the same thing to your foreground by scraping some rock shapes in the area where you placed the gray color (fig. 87).

Look at it and decide whether you need or want more. If you do, add them while the paint is still wet.

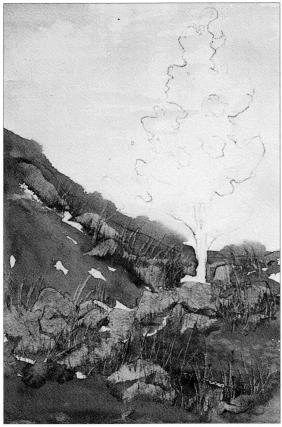

*Step 3: credit-card rocks.*                    **Fig. 87**

**Step 4.** While that paint is still wet, or at least while the puddles left at the base of your rocks when you scraped them are still wet, flick up some grasses out of those puddles using a damp brush you have twisted against the palm of your hand to fan out the bristles. Let all of this dry completely.

**Step 5.** Wet your sponge and squeeze out as much water as you can. With the damp sponge pick up a light value of either orange or a mixture of red and yellow. Pat some of this color into the foliage area of your tree drawing. While this is still wet, pick up a darker value or color on the sponge. I used pure alizarin crimson. Take this color and pat it into the wet areas of orange. They will blur a little. Look at your sponge patterns. Are they light and leafy, or are they wet and blobby? If they are blobby, remove them with a crumpled tissue and let the whole area dry before starting again.

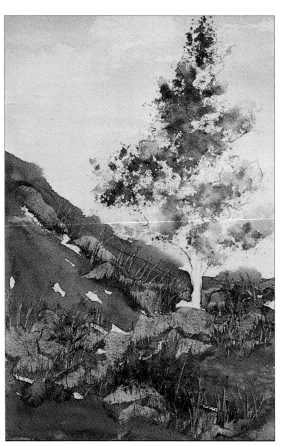

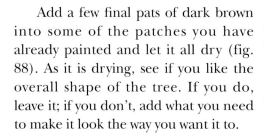

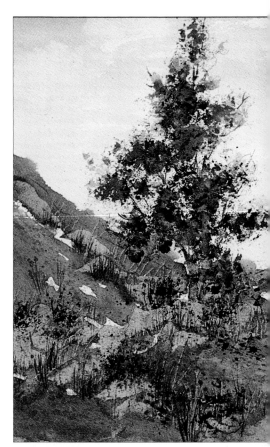

*Step 5: add the foliage areas to the tree* **Fig. 88**
*with a sponge.*

*Step 6: add trunk and branches by* **Fig. 89**
*"brush printing."*

Add a few final pats of dark brown into some of the patches you have already painted and let it all dry (fig. 88). As it is drying, see if you like the overall shape of the tree. If you do, leave it; if you don't, add what you need to make it look the way you want it to.

**Step 6.** While this part is drying you can add the trunk and branches of the tree. Use the color that you mixed for your rocks, a gray made by mixing blue and brown. Rather than stroking in that color, pat in your tree trunk using the thin edge of your aquarelle brush held perpendicular to the paper, and touch small, consecutive skinny lines into the trunk area. They will bump into each other, leaving little white skips and sparkles and, while they are at it, give you a very realistic tree trunk (fig. 89). Painted tree trunks and branches have a way of appearing too flat. This will give you a realistic trunk-and-branch texture that will complement the foliage. I call this technique "brush printing"—you will use it later in this same painting when you make grasses.

**Step 7.** First, look at what you have done so far. I completed the painting by brush printing some grasses into the brushed grass area I had already

*Step 7: grasses, splatter, and nicks*    **Fig. 90**
*complete the piece.*

created at the base of my rocks. I did this in the same way I made the tree-trunk texture. To create grasses, I just made the same skinny marks I used in my tree trunk, only farther apart. I also made some small dark sponge bushes along the rock shapes using my damp sponge and dark brown paint.

The next-to-last thing I added was some dark fine splatter, using dark palette dirt and patting some splatters from my brush onto the foreground of my painting along the direction of the landscape contour.

The last touch was in fact a scrape and a nick. I added the little white

grasses and flowers you see by scraping and scratching flower and grass shapes with the point of my Swiss army knife (fig. 90). I could have used the corner of a razor blade as well.

I am pleased with the result. If your subject is a birch tree leave the trunk unpainted and therefore white, and scratch your branch shapes with the tip of a knife or a razor. Keep in mind also that birch leaves are more of a gold/yellow than a red/orange before they turn brown. Observation is always the best teacher, and practice is the next. Use them both well.

Chapter 9

# Demonstration V: A Snow-Covered Pine Tree Using Combined Wet and Dry Techniques

*"The Snow Tree"*

---

**Materials**

| | |
|---|---|
| Paper | 7-1/2" x 11" (horizontal) |
| | d'Arches 140 cold pressed |
| Brushes | 1" aquarelle |
| | #3 or #4 rigger |
| Colors | Antwerp blue |
| | warm sepia |
| | olive green |

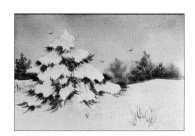

---

So many people have asked me how to paint snow and snow-covered trees that it makes sense to include it here.

The secret to painting effective snow is to plan where you want it to be and then don't paint it. If that sounds a little crazy, it's not. The best snow effects are created by leaving the white paper unpainted and using it for the white snow areas of your painting. All it takes is careful observation and reasonably careful drawing of your snow areas.

**Step 1.** Draw a horizon line all the way across your paper, just above or below the center point of your painting area. Drawing it right in the center will divide your painting in half visually, and you want to avoid that.

To this line, add a drawing of a tree with great, lovely piles of snow all but obscuring its branches. I used a photograph I had taken. If you don't have a proper photo, copy my drawing (fig. 91), taking care to draw the snow piles

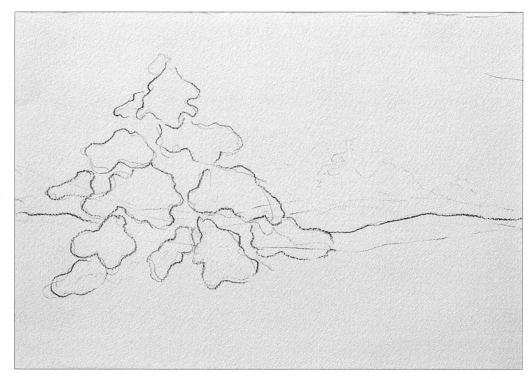

*Step 1: initial sketch. Note position of horizon line.*

**Fig. 91**

very carefully and keep their individual shapes distinct from one another.

[A note on winter painting: Follow the rules for winter camping. Dress warmly and loosely. Preplan so you are dry and out of the wind. You will need dark glasses to protect your eyes from snow glare. Glycerin or salt will keep your water from freezing. Beware of hypo-thermia because you are sitting still and can get absorbed in a painting and not realize how cold you are. Painting from a car, looking out a window, or taking photographs and painting later in your studio are good alternatives. Personally, I prefer not to work outdoors when its cold. When I teach winter painting or do it myself I work in the warmth of the studio from my own sketches or photographs. Of course, if you are one of those hardy souls who loves working in the cold, by all means

do so. Just remember to follow the rules cited above.]

Once the line and the tree are drawn in place, wet the upper part of your paper with clear water all the way down to the line you have drawn, taking care to stay completely out of the tree area.

Into that wet area swish a cool gray sky color with your 1" aquarelle brush. I used a gray mixed from Antwerp blue and warm sepia. You may choose to lift out tissue clouds, or you might decide to leave it alone. I left this one alone.

Keep your darker value at the top of the sky and the lighter value near the pencil horizon line (fig. 92). You are doing this to mimic what the sky does and because you want a light value against which to plant your background of middle-value trees.

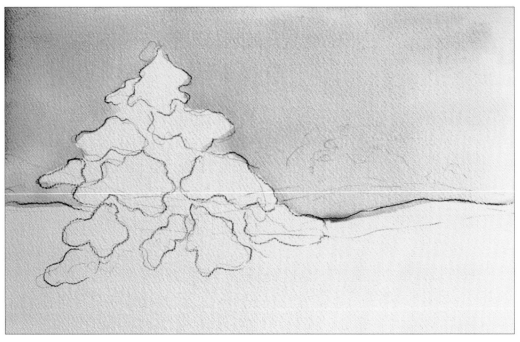

*Step 1 (cont.): sky color added.*  **Fig. 92**

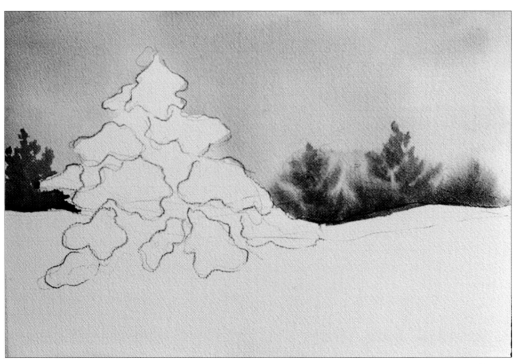

*Step 2: horizon line of background trees against the wet sky.*  **Fig. 93**

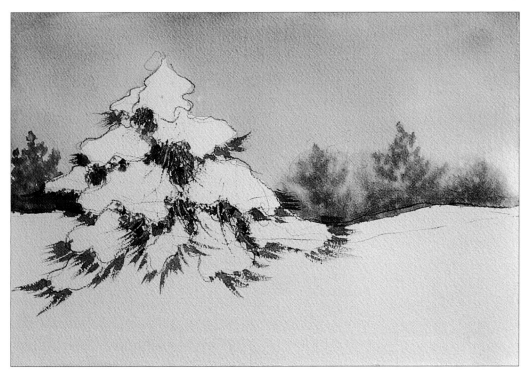

*Step 3: defining snow piles on tree branches.*                    **Fig. 94**

**Step 2.** Using a darker value of your sky color and the wet method of painting trees demonstrated in Chapter 4, tap in a line of trees of differing shapes and sizes while the sky area is still wet. Do this all along the line except where the foreground snow-covered tree is going to be (fig. 93). If the trees blur out too far and too fast, wait for a minute or two and do it again when the wet sky has dried up a little. Let this stage dry completely.

**Step 3.** Start to define the snow piles on the tree branches by painting the wispy shapes that appear beneath the piles. Do this by mixing a cool color of Antwerp blue, olive green, and a little touch of sepia to make it darker than the background trees you painted earlier. Place your brush at the base of each snow pile and flick it out and to the side in a quick motion. You should

end up with an odd shape that resembles an eyelash, dense in color and value right under the snow mounds and soft and whiskery around the edges (fig. 94). Repeat this until you have defined all of the bottoms of the snow mounds on the tree.

If you have a snow mound that overlaps another snow mound with no defining branches, you can define it by wiping in a little very light blue at the base of the top mound, overlapping the one below it. You'll see this in the finished picture of the demonstration, up at the top of the tree. This is called casting a shadow. You can repeat this on other snow mounds, even where some branches are sticking out. It gives a very pleasing effect.

You can also cast a shadow or two underneath the whole tree. Doing this will make your tree appear to sit in the

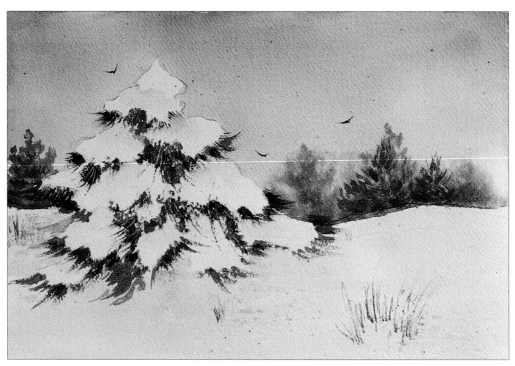

*Step 4: pulling it all together with finishing touches: wispy grasses, needles, and a few birds.*

**Fig. 95**

snowy foreground rather than float above it.

**Step 4.** Finishing this painting involved using my rigger to add a few wispy grasses sticking out of the foreground snow, just the way they do in nature. I also used the rigger to add wispy-looking pine needles peeking out from under my snow mounds on the tree. My final addition was a few little splats of very-light-value splatter in the foreground underneath the grasses that had just grown out of the snow, and flicking in a few birds to mask the splats that got away and landed in the sky (fig. 95). (It even happens to me!)

There you have them: five lessons on five landscape subjects. Now you are going to move on to some other ways of thinking about and making your paintings. Once you have more or less mastered the basic, literal techniques, the next logical step is to get creative with them and make them uniquely your own.

# Section III

# Getting Creative—The Next Steps

# Chapter 10

# The Nature of Painting, the Nurture of Art: Landscape Techniques

In the next few pages I'd like to help you push your painting—and your seeing—beyond what is in front of you. You may like this way of painting, you may not—but once you've honestly tried it you can make a more deliberate decision about the nature of your own art making. I said in an earlier chapter that I do not personally favor realistic representation over abstract expression. As a teacher, I think a person wanting to know how to paint should be familiar with the techniques of both styles and should understand their merits and inherent differences.

With that in mind, I will show you some exercises and techniques that lead to a more personal and creative expression of the subject of landscape painting.

### The Mind-Doodle

I cannot leave the everyday world and enter my own world of art making without a transition period. For me it comes in the form of a visual meditation, or what I call a mind-doodle. To clear my mind of the mundane and to prepare myself for painting, I will often take a large sheet of inexpensive "junk" paper—brown wrapping paper or even newspaper will do very nicely—and just make random swirls and sloshes on it. Sometimes I use palette dirt, that wonderful goo, often a perfect neutral, that collects in the corners of my palette. Sometimes I use my watercolor crayons, spray bottles, colored inks or pencils, or a combination of all. Other times, especially if I am out on a jaunt or a trip, I have to contain my actions due to limited supplies. Then I doodle away on my sketch pad or even the back of a check or deposit slip. I doodle with a pen or pencil if water or space is limited.

My mind and my hand take flight in the use of textures and values. If you do this for its own sake several things will start to happen. One is that you lose yourself in the process (a Chinese

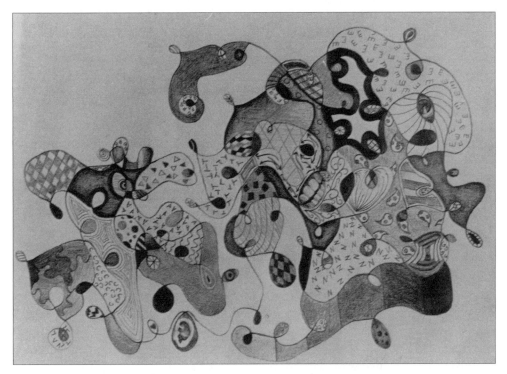

*The mind doodle.*                                                    **Fig. 96**

artist said, "He only truly draws when he forgets who is holding the brush"). Betty Edwards, in *Drawing on the Right Side of the Brain,* describes this feeling or experience in her directions for contour drawing and upside-down drawing exercises.

When doodling in this way, don't rush. I keep my doodles nonrepresentational—just wiggles and squiggles and shapes (fig. 96). Later I add textures and values. Sometimes words or alphabetic calligraphy will creep in, and that's just fine. But my start is always unformed and unconsciously directed.

Doodling like this is very soothing. My students love it and I try to start each lesson with this period of visual meditation. It frees the artistic spirit and gives it a place to flower.

Once you have doodled to your satisfaction (and even if you haven't) you might want to try some creative "jump-starts." These are techniques that take the edge off confronting the glaring white, pristine, expensive, unblemished paper innocently staring up at you. Sometimes they determine the direction of the rest of the painting, other times they will be merely a colorful start from which a work of art may or may not grow.

Let's look at some specifics and see whether they might fit into your painting vocabulary. Even if you don't want to use them for now, read about them and save them for later when you might be feeling a little stale.

## Some Creative Approaches to Landscape Painting

### An Interrupted Wash

There are times when deliberately interrupting a background wash will have some marvelously creative accidental side effects.

This technique is sometimes used as an "underpainting." As mentioned earlier, artists use underpainting to precolor or tone a piece of paper before starting to paint the actual subject matter on top of it. The result is that areas of the painting, instead of being white if left unpainted, will be the color of the wash underneath. This produces some wonderfully spontaneous effects of color in the finished painting. Here is how to do it.

**Step 1.** Lightly spray your paper with your spray bottle. Don't soak it, just dapple it with water.

**Step 2.** With the largest brush you have, slosh on a light-value splash of any color in a broad horizontal or vertical pattern. Do not make diagonals, Xs, or crisscross marks! They will be much too assertive later and will be almost impossible to work with.

**Step 3.** You might add more color to this by following your established pattern with a few whisks or touches of a darker value or another color. Don't use complementary colors when you

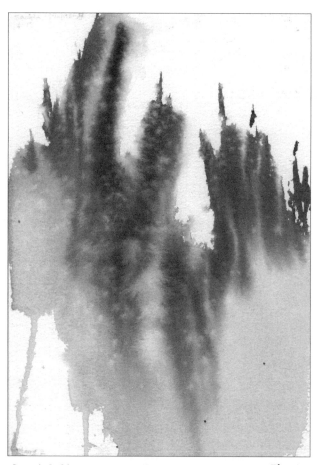

*Step 4: hold paper up to achieve a vertical run.* **Fig. 97**

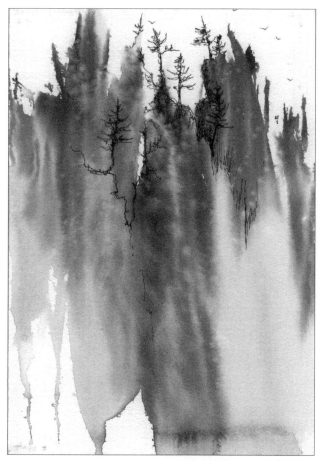

*Step 5: a continuous line drawing on an inter-* **Fig. 98**
*rupted wash creates and abstract landscape.*

do this, though, or you'll get a neutral gray, or worse, mud!

**Step 4.** Let this dry until it loses its shine. Then use a quick shot with your spray bottle or flick a few fingers full of water into the drying wash and let it run by holding your paper vertically for a few minutes. When it stops running or you like the pattern, lay it flat and let it dry (fig. 97). If you are in a rush use a hair dryer or the sun. Don't try this technique in a tent in the rain. It won't work, because it will never dry.

Here's a practical hint for you. Do a number of these at one time so you'll have them ready when the mood strikes to do more with one or when you want to try using this pretinted background out in nature. This will save time by elimating the drying process.

**Step 5.** Now you have a background just waiting for a foreground. How to proceed? One way is with a continuous-line drawing in ink that ignores the background patterns and just happens—a sort of mind-doodle with a purpose.

A continuous-line drawing starts somewhere on the subject, much like a contour drawing, and just keeps going until the drawing is done, with the pen or pencil never leaving the paper (fig. 98). To change direction or to start another object in the drawing, the

line, followed by the artist, must return to some neutral territory and then proceed. If your background is very light, an ink lighter than black might be better visually. Good art needs some contrast but too much is like garlic: it takes over the stew and confuses the issue. This, incidentally, is exactly how I do many of my own paintings. If you try it, you'll see that the technique has enormous creative potential.

### The Underpainted Wash with Negative Painting

Another way of using underpainting is to paint the negative shapes—paint *around* what you want to say and let the images fall out. Barbara Nechis is an accomplished artist and writer and very creative at using this technique. Her book *Watercolor: The Creative Experience* (North Light, 1978) gives an excellent and very thorough description of this approach to painting. I'll give you a brief one.

**Step 1.** Start with a completely dry underpainted background done in the way I have just described, and lightly draw in your subject matter over the abstract shapes as we did before. I'll use trees (fig. 99).

*Step 1: start a negative painting with a sketch over an underpainting.*          **Fig. 99**

*Step 2: example of negative painting over* **Fig. 100**
*underpainting.*

**Step 2.** Continue by painting the spaces in between the trees, branches, and foliage in a slightly darker value (fig. 100). You can use the same color or a closely related (analogous) one found on either side of it on the color wheel. If you use a complement (i.e., a color from the opposite side of the wheel), you will have neutral tones, that is, shades and varieties of gray. If you want that look, do it, but analogous colors, all warm or all cool, will give you a more colorful result.

**Step 3.** When that is completely dry look at it and decide again where to go. You can proceed with a darker value and enhance some of the shapes to make the tree form really stand out, or (as I did) add some more vertical lines to suggest more trees.

### Toothbrush–Splatter and Stencil Overprinting

I did not mention the toothbrush in the equipment chapter because I listed only the bare essentials. A toothbrush has a number of uses in watercolor painting but they usually happen in the studio rather than on the trail, so keep one handy when you are in the finishing stages of a painting at home, or in your studio.

To make toothbrush splatter, which is much finer than paint brush spatter, you must first have an old toothbrush. You should have one in your supply box for scrubbing out mistakes. Mix the color you want to splatter on your palette and dip your toothbrush bristles into it. Tap off the excess water and hold the toothbrush with the bristles toward the paper. Using the tip of your forefinger, scratch or scrape the bristles in such a way that little splatters of paint fly onto the surface beneath (fig. 101). You'll quickly learn how much water and paint you need to accomplish what you want to do.

There are any number of uses for this. You can splatter-print large leaf shapes by laying some real leaves over your paper and using a toothbrush to make very fine splatter over and around them as they lie on top of your

*Toothbrush splatter: starting position.*

**Fig. 101**

*Overlapping leaf shapes in toothbrush splatter.*

**Fig. 102**

painting (fig. 102). Keep the value of the color you splatter quite light. You want to see just a hint of the overlaid pattern and not a hammer blow.

This same technique, using white paint, will produce a very nice snow-storm. Using it on dark-colored paper over some white "line" trees will make a lovely set of holiday greeting cards with a winter theme.

For a very different approach, make a splatter-stencil print using a gold or silver paper lace doily. Place the doily shiny side up and splatter with very fine splatter all over and around it. When you carefully remove the doily, your painting will show a splatter painting of the negative doily shapes in a lacy pattern. In the right painting, this technique is a dazzler! Use foil-covered doilies because they don't curl when they get wet; one or two doilies will last you forever! Also, practice this on another piece of paper before you try it on the real thing.

You can add other shapes—people, birds, flowers, etc.—by painting them in with a brush or drawing them in with a pencil or pen. Sometimes a painting needs a few more visual clues to complete the visual statement. You are the judge.

*Scrunched plastic wrap.*                    **Fig. 103**

*The result.*                    **Fig. 104**

126    *Section Three*

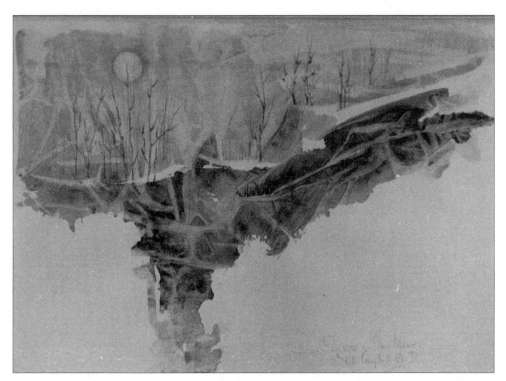

*"Sunrise in New Mexico."*                                         **Fig. 105**

## Plastic-Wrap Fractured Underpainting

This technique is far more gentle than it sounds. Take a piece of low-budget plastic wrap; a generic brand is often the best, because the good stuff is too thick and doesn't produce as attractive effects. Take a juicy brushload of color, maybe even two colors on the same brush, and make a big, broad squiggle slightly off center on your paper. If you don't have two colors on your brush, you might want to touch in another color or two while your first squiggle is still wet.

Move quickly now, while the paint is still wet. Lay your piece of plastic wrap over the wet paint and push it down and in from the outside edges, toward the center of the squiggle (fig. 103). A fractured pattern will appear that looks somewhat like a stained-glass window under the plastic wrap. A few paint bloops might escape, but that's what we want. Remove your hands. Now, let this dry for at least one-half hour or more before lifting off the plastic wrap. That fractured–stained-glass painting is now on your paper (fig. 104); it's up to you and your imagination to decide what to do with it. The vaguely geometric pattern often suggests a rocky outcropping and just yells for some trees to sit up on it (fig. 105). You can vary this idea by drawing a shape and filling it with wet color, then pressing the plastic wrap onto it.

## Mixed Media or Collage

You can make a landscape collage by adding bits of paper, torn or cut, or even photographs to your painting. Try this as an example. Tear some long, narrow strips of newspaper. The classified-ad pages are good, and so are the stock pages because the print is fine and it has an overall pattern. Telephone books are good, too! Paste the paper strips down vertically on your paper using a glue stick or a half-and-half mixture of Elmer's glue and water.

Now look at this as the beginning of a landscape and see where the idea takes you. Note how I worded that: where the idea takes you. If you let yourself be carried into the creative process it will work far better and happen more quickly than if you stand there with clenched fists and gritted teeth, demanding that some poor innocent idea spring forth. Rather, paste down your strips or make your plastic-wrap squiggle, and leave it alone for a day or two. When you

*"Enter Ye."*

**Fig. 106**

*"Untitled."* **Fig. 107**

return to the work, ideas will be tumbling all over themselves and you'll achieve some marvelous results. Figures 106 and 107 suggest some possibilities.

You will dream up many more variations on your own if you try all of these techniques because one off-the-wall idea just naturally leads to the next! And after the initial uncertainty of it, if you listen to the quiet the answer will come. It's always been there—only most of the time you're so busy ranting and railing or trying to predetermine it that the poor little answer gives up in despair. Make room for the birds; give voice to the secret thoughts and ideas that are all there in the wings just waiting for their entrance cue.

If you have read all this and done the exercises, you are ready to move on. The next chapter has some ideas that build on the previous ones and makes some suggestions for further growth in new directions and even some new places.

# Chapter 11

# Expanding Your Horizons

Under the heading of "little miracles" or "unexplained gifts" comes the following story. It was brought to mind by a phone call I received as I was writing this book.

In September of 1990 I received a greeting card, addressed to me at Lesley College. It was a small watercolor painting that was a lesson taken from my first book. I recognized it but not the name on the card's return address. A letter accompanying the card said, in brief, that the sender, whose name was Lu Burroughs, hoped I was still at the college and that her letter would reach me even if I were not. I was and it did. She went on to say she had received my book as a Christmas gift and was so pleased with her painting efforts that she wanted to share one with me. She concluded her letter with a poem she wrote:

A Grandma Moses I will never be
As by this card you can plainly see,
But, I'll keep trying and you can bet
That I'll master this job yet!

She ended with the fact that she wasn't quite sure how far she would get with this new venture because, at age 87, things happen a little more slowly! She didn't regard age as a real problem, however, and she would joyfully go wherever this new adventure took her. Since that time we have corresponded and exchanged photos, little gifts, and immeasurable quantities of humor and inspiration. Lu sent me two crocheted hats last year. She made them herself and assured me that part of her longevity and good health is attributed to the fact that she rarely gets colds because she always wears hats. I have two hats and, according to our recent phone call, two more are on the way. I plan to be very healthy.

Lu is filled with gratitude for the gift of life and good health, and just as filled with the desire to learn, grow, and create. Anyone who thinks he or she is too old, too tired, or too stuck to learn something new should meet Lu Burroughs (fig. 108). She made forty or fifty hand-painted Christmas cards last year. After the start of the new year,

*Lu Burroughs*                    **Fig. 108**

she planned to try her hand at oil painting. She received oil paints as a Christmas gift and can't wait to see what she can do with them. This, of course, will happen after she finishes sewing herself some new clothes and writing a poem or two—she's a practicing poet as well. Some lady.

Lu is still expanding her vistas. So can you. What follows is a number of practical suggestions of things to do and places to go to expand your knowledge and experience as you explore this wonderful world of art making. In so doing, you'll get to know your world and yourself on a very different plane.

## The Local Art Show

This may take place in your library, on the town green, or in a church. It may or may not be juried and it might well be a collection of some of the more trite and clichéd renderings of kittens, postcard barns, and old mailboxes. But within those halls, you will find more love and pride than you'll ever find in a plush gallery on Newbury Street or Madison Avenue. Here also, you might well find one or two real treasures—sometimes many more. Go to these local events for two reasons: first, to support the local art community, which always needs help; and second, to be inspired. You'll find a color combination you might like to try, a subject

*Visitors at an exhibition.*                                       **Fig. 109**

or a place you might like to visit, or a technique you've not attempted or even known about (fig. 109). When you are at one of these shows, talk to the artists and hear them firsthand, if possible. You'll hear some wonderful stories. Also, seize opportunities to talk to one or more of the judges at local and community shows. Ask them what they were looking for (all judges are different!) and how these particular prize winners demonstrate those attributes. Ask the judges or the artists themselves for recommendations of books you might read or other artists with whom you might study. In other words, make contact; make a personal contact. Artists love to talk about their work.

### Galleries and Museums

Depending on where you live or travel, go to art galleries and museums whenever you get the chance. I am one of the herded hordes who shuffled through the Renoir, Monet, and Wyeth's "Helga" shows at the Museum of Fine Arts in Boston, and I am far richer for it. There is a profound delight in seeing a painting "in the

flesh" that you had heretofore seen only in art books, slides, or greeting cards—and by the way, don't neglect those greeting cards! Many people lump all greeting cards together with "velvet Elvis" paintings. This is not at all the case. Many, many greeting cards are in my picture file, and they are not just the "fine art" museum-reproduction cards. There is some very fine and inspired art on greeting cards; do take the time to really look at them. They could be a great springboard for a new painting. Use them for inspiration.

## The Picture File

Almost all artists keep a picture file of ideas and references. Sometimes you need a certain type of tree or flower or other image to complete a painting. Until Christmas 1990, my picture reference file was a pile of ragged envelopes, poorly labeled and stuffed to overflowing with photos that others and I had taken over the years. These, plus some great greeting cards, favorite reproductions, Avon calendars, magazine cut-outs, and miscellany too various to list. It all commingled, mixed itself up, fell on the floor, got stepped and splashed on, and was generally inefficient. That year, an organized friend gave me an expanding file with a latch and a handle. I've been compact and organized ever since, and it's wonderful. My picture/idea file is organized alphabetically by subject: animals, boats, buildings, flowers, people, Southwest themes, trees, winter themes, etc. Both my students and I

frequently dive into it when we need a new idea or to clarify an old one. I weed out my picture file about once a year, but these castoffs often become part of my mixed-media collages, so they are never really wasted. I'll often cut or tear them into smaller pieces and glue them into a piece I am working on.

Along with a picture file, you might keep a "pretty paper" file (pile?) with lace doilies, textured rice paper (see appendix), tissue paper, some wrapping paper, and even some wallpaper.

By now you must think that to be an artist you need a warehouse for supplies. This is partially true, but be selective and weed out on a regular basis what you are not using. Any nursery school, day-care center, or school art program will be only too glad to get your surplus. It's a great way to recycle.

## A Camera

Your camera is an invaluable tool. More and more artists carry an inexpensive "point and shoot" automatic-focus camera for quick reference shots. This is especially true for those who prefer studio painting of landscape subjects to on-location tussles with the elements. Should you forget your camera, you can always buy an inexpensive disposable camera at almost any multipurpose drug store or convenience store. Be sure it's made of recyclable plastic and recycle it when you are done!

## Classes, Workshops, and Seminars

You can't beat the experience of total immersion with other people that a class or workshop affords (fig. 110). Whether it is a day or a week or longer, the chance to be in a place that is not your home or studio with no purpose other than to learn and to paint is like nothing else. In the workshop setting your phone will not ring, someone else cooks, and your dog does not need to be let out. You have time to explore new ideas or revisit old ones and the space to play them out. I come back from these occasions totally energized, whether I teach it or take it. Some classes are available at the Appalachian Mountain Club facilities at Pinkham Notch (fig. 111), Bascom Lodge, and the Catskills. (See the index for other places to find good workshops and seminars.) If you go to another part of the country to take a workshop, you learn to see a new environment as well.

One of my nicer experiences in this milieu, besides the AMC, is a delightful art school/resort in Ruidoso, New Mexico, called Carrizo Lodge. Bordering the Mescalero Apache nation, it offers fine teachers and a unique setting high in the Sierra Blanca Mountains about three hours south of Santa Fe. Like the AMC people, their commitment is to art and the artist in harmony with the surroundings. Carrizo has all the majesty New Mexico has to offer and very little of the "IwannabeanIndian" commercial-

*Total immersion: a workshop in the author's studio.*     **Fig. 110**

*Workshop at Pinkham Notch.*     **Fig. 111**

ism that has consumed so much of Sante Fe and other cities in that state.

If you can't afford a week or a weekend away, try taking a class or a one-day workshop with a local or visiting artist. Many local art associations offer these workshops at very reasonable prices. Ask questions, read art magazines and local arts publications, and even check your local community colleges and adult education programs. They can be the source of a hidden treasure.

Finally, if a regular class is out of the question for time or financial reasons, join an art association and go to artist demonstrations when they are offered. This is where a professional artist is hired to come in and demonstrate how to do a specific painting or technique. It's great fun, usually lasts less than two hours, and most often leaves you full of ideas. Often there is a coffee hour afterwards, when you can talk to the artist and ask questions.

*The author demonstrating a technique at a workshop.*     **Fig.112**

The enthusiasm of the guest artist and the audience is contagious, and you can't help but be inspired. Also, the artist will describe things in her own way, and that can be valuable. You may hear the same thing said in many ways or read about it in a number of books, but one day a concept that had been obscure suddenly becomes clear because another human being found the way around your learning block.

## Books and Magazines

In between workshops, demonstrations, classes, and seminars, read whatever you can get your hands on. In the bibliography is a list of books and magazines you will find useful. Pick up one of these pretty, glossy art books or monthly magazines and read a paragraph or two, or even just look at some of the pictures. You will be inspired. I keep one set of art books within easy reach in my studio for my students and myself. In fact, I often encourage them to sit and read awhile if they are having trouble getting started. I keep another batch at home. Include art-history and art-appreciation books in your collection. These are great to help you understand today's imagery and to help you see that so much of what we do is built on a respected and ancient tradition. It always works for me.

## Entering Shows

Finally, let me strongly suggest you enter some shows yourself. As soon as you feel your work is as good as any you see in the shows you attend, get out there and give it a try yourself. Local organizations have them regularly and provide a set of guidelines for entering. You must follow them to the letter, or you won't be allowed to compete.

When you do enter a show, carefully observe the framing and wiring regulations. These rules are written for the safety of the art and to present the art in its best possible format. At a show volunteers catalogue the work and stack it in categories. Those people whose work has been accepted for the show and who have won prizes are usually notified by postcard or telephone call.

The judges at a show are recognized professionals in the field and are usually paid a token fee for their time. Most often more than one judge is used, and their combined expertise (and compromises) will determine what will receive special honors. It is never an easy job, because a good judge knows his/her field but is always aware that the artwork they judge was done by people just like themselves, full of hope, pride, and just a touch of anxiety about the whole thing.

## Buy Yourself a New Toy

How quick we are to buy a gift for a loved or even a "liked" one—and how slow we are to do it for ourselves. Try this: Go to your favorite art store, or open up your favorite art-supply catalogue, and select something that you don't usually keep in your supply box or studio. It can be a new color with a weird name. Try opera, a truly spectacular color put out by the Holbein company. Try a new paper, or a new brush, or see what some of those Caran d'Arches watercolor crayons will do for and with your imagination. (I have mentioned these crayons a number of times. I use them a lot because I can achieve an effect with them that is midway between painting and drawing. They look and act like regular crayons until you wet them with either a brushload of water or a spray bottle. Then the fun begins. I do not have them in my field kit because they take up more room than I have, and they have a tendency to roll around and drop to the ground. This is awkward. But for studio work, or by themselves for color sketches, they are wonderful. Not all art stores carry them, but I've noted two in the appendix that do.)

Then there is always the opposite tactic. Instead of expanding, try limiting yourself. Try a painting using only ultramarine blue and burnt sienna. These are complements, so one of the range of colors they will produce is a perfect neutral grey. But the range of tones, hues, and values you can achieve with these two is amazing. If you try this, don't forget to use them in their pure or unmixed state as well. These two colors make great landscape pictures. This technique, by the way, is referred to as painting with a "limited palette." There is nothing wrong with it; Picasso and Braque used the idea extensively while producing some of their famous cubist pieces in the early twentieth century. If they can do it, so can you.

Finally, a word about expanding the *inner* horizon. *You* are the first and last tool of painting.

Sales, prizes, and quantity of paintings produced per year do not make you an artist. Each artist is the sole proprietor of his or her soul and the direction it will take.

I remember visiting an artist, then an old man, with whom I had studied life drawing and for whom I had modeled on occasion. He had invited me and an artist friend for an Italian dinner he was going to prepare for us.

His apartment was a Spartan walk-up efficiency on a third floor in Boston's Italian North End. As we talked before and after the meal, my friend kept pressing the old man to paint again. He had by then stopped painting and drawing for some years, although he still taught. Finally, in gentle consternation, the old man turned to the window and the sunset then taking place over the city and the water that surrounded us on three sides. He sat transfixed, his hands on his knees, his old eyes squinting against the warm light that filled the room. "Look at that," he whispered, "look at that. If I was still painting, I'd be too busy trying to do it, and I wouldn't be able to see it. There's so little time left. I don't want to miss anything."

I was profoundly moved and have never forgotten that moment, or his wisdom.

That is the real message of this book. Most of us still have time both to see and to do. You will find that by drawing and painting the landscape, you will see it as you never have before. The sunlight that used to cheer us and dry out our sleeping bags suddenly becomes a star performer in a painting by creating patterns on a river or forest floor that previously we might not have noticed.

Artists are observers. First and last, we are the watchers, the interpreters, the recorders, and, ultimately, the visionaries.

As you hike, climb, fly, or meditate, you are not far from some growing or flowing thing. Through the act of painting and drawing we can appreciate this far more than we did before we undertook this act of visually marking our history and our present.

I have shared with you a piece of my journey. I hope I will have the grace to meet some of you in person along the way—in a workshop, at a show, or on a side street in an obscure town in New Mexico. Please come up and say hello—I will be so very pleased to meet you.

# Appendix

I am one of those people who often wonders, Now what do I do? Where do I go from here? When I ask that I want specifics, so I thought I'd list some places I trust to buy supplies, and sources to find the information you'll need to continue growing as an artist. All of these names and places I can personally recommend because I have been dealing with some of them for as many as twenty years, and because they have been so reliable I am happy to pass them on to you. This will be especially helpful to those of you who live in rural or other areas where good art supplies and reading materials are not readily available.

## Supplies and Suppliers

**Retail Stores** (a little more expensive than catalogues, but the personal attention and understanding are well worth it)

1. Golden Gull Studios
   South Park Avenue
   Plymouth, MA 02360
   Tel. 508-746-8091
   FAX 508-746-8640

General supplies, watercolor crayons, books, custom museum-quality framing, art gallery. David and Frimma Buckman are your hosts. Call or FAX them and they will personally fill your order and help you with the specific materials suggested in the book. Their custom framing is worth the trip.

2. "me" Judy Campbell
   1405 Hanover Street
   West Hanover Plaza, 2d Floor
   Hanover, MA 02339
   Tel. 617-826-8763

This is my studio address and you may visit it by appointment. You can also arrange to have me teach a workshop in your area. Call and leave a clear message with the date and time of your call. I have an adequate supply of black-and-white copies of *Basic Watercolor Painting* (Book #1). The price is $18 and includes postage and handling.

For the Field-Pack Studio—everything you need to paint anything anywhere—send $55 to cover the kit, postage, packaging, and sales tax. The F.P.S. is the perfect watercolor starter kit.

## Catalogues

1. Art Supplies Wholesale
   4 Enon Street (Rte 1A)
   North Beverly, MA 01915
   Tel. 800-462-2420
   508-922-2420

Friendly people, good prices.

2. Daniel Smith, Inc.
   413D First Avenue South
   Seattle, WA 98134
   Tel. 800-426-6740
   206-223-9599

Nice catalogue. Many unusual items you can't find anywhere else.

3. Napa Valley Art Store
   1041 Lincoln Avenue
   Napa, CA 94558
   Tel. 800-648-6696
   FAX 707-257-1111

Nice people. Good prices especially on paper. They carry opera pink!

4. Utrecht Manufacturing Corp.
   33 35th Street
   Brooklyn, NY 11232
   Tel. 718-768-2525
   (Orders) 800-223-9132
   FAX 718-499-8815

Excellent prices and good service.

## Workshops, Programs, and Seminars

1. Appalachian Mountain Club
   Locations—Pinkham Notch, New Hampshire
   —Bascom Lodge in the Berkshires in western Massachusetts
   —Catskills

You should become a member of this fine organization. The settings are beautiful, the staff is enthusiastic and supportive, and the food is the best. (Thanks, Dave!) The accommodations are clean and comfortable and there's camping nearby. For information call AMC headquarters in Boston at 617-523-0636. There are lots of workshops and weekend offerings available. Look into them all.

2. Carrizo Lodge (ask for Darlene Nelson)
   P.O. Box 1371 - in 513
   Ruidoso, NM 88345
   Tel. 505-257-9131 x. 412

Bordering the Mescalero Apache nation, this place is not to be missed. Great studio space, spectacular view, native color and history, Old West flavor...real! Great food. Good-to-great accommodations. Campgrounds nearby. Five stars! Lots of workshops running concurrently.

3. Lighthouse Arts Gallery (ask for Steve)
   545 Highway 101S
   Crescent City, CA 95531
   Tel. 707-464-4137

Art gallery and teaching studio. Has some of the finest artists and teachers in the country. Northern California is like no place on earth—the trip is worth it. Call for brochure.

I have had firsthand (brush) experience with all of these people. For a full list, get the annual March issue of *The Artist's Magazine*. It usually lists workshops happening all over the United States and abroad. Don't be afraid to call and ask questions—lots of them—if you are thinking about taking one of these workshops. They can be costly and you deserve to get your money's worth.

Finally, two magazines, *American Artist* and *The Artist's Magazine,* are the best sources of all for workshops, supplies, and timely and informative articles. I would subscribe to at least one. Both are good.

The next step is yours. Take it and grow. Get a book, take a course, attend a lecture or a workshop. Buy yourself a new toy and color your world—your way.

# Bibliography

I think you'll find these books both enjoyable and helpful.

1. Blockley, John. *Country Landscapes in Watercolor.* New York: Watson Guptill, 1982.

When you are ready to get creative with your landscapes, read this. Truly fresh vision, very well explained, and beautifully illustrated.

2. Campbell (Reed), Judith. *Basic Watercolor Painting.* Cincinnati, OH : Northlight, 1982.

Basic-basic-basic landscape techniques. Currently out of print, but available in some libraries. I have made a black-and-white spiral-bound copy available by mail for $18 (see Supplies and Suppliers for ordering information).

3. Edwards, Betty. *Drawing on the Right Side of the Brain.* Los Angeles, T. P. Tarcher, 1979.

Another classic. Everyone should read it and own it.

4. George, Ethel Todd. *Flower Painting.* Cincinnati, OH: Northlight, 1974.

A nice, easy read that says it all about flowers.

5. Goldstein, Nathan. *The Art of Responsive Drawing.* Englewood Cliffs, NJ: Prentice Hall, 1977.

A beautiful, sensitive book on drawing—and how to see and understand drawing as well as do it.

6. Masterfield, Maxine. *In Harmony with Nature.* New York: Watson Guptill, 1990.

Note pp. 41 and 84—these paintings are by Edna Rideout, a dear friend and very creative artist.

7. Nechis, Barbara. *Watercolor, The Creative Experience.* Cincinnati, OH: Northlight, 1978.

Yet another classic. Barbara Nechis brilliantly explains creative watercolor-painting techniques. She makes it do-able for the timid. She's also an excellent teacher and workshop leader. Experience her however you can.

8. Orban, Desiderius. *What Is Art All About.* New York: Van Nostrand Reinhold, 1975.

One of my bibles. Probably out of print, but worth hunting for. He wrote the definition I use of art vs. craft.

9. Reid, Charles. *Painting Flowers in Watercolor.* New York: Watson Guptill, 1978.

Anything by Charles Reid is a treat. He's a gifted painter, an even more gifted artist and teacher, and a writer and celebrator of the creative spirit. Read his books, and by all means take a workshop with him if you can.

10. Richards, M. C. *Centering.* Middletown, CT: Wesleyan University Press, 1962.

A classic! Deals with the soul of the artist as well as the skill of the potter.

# Index

# About the Author

Judith Campbell is a professor of art at Lesley College in Cambridge, Massachusetts. She has been painting, writing, and teaching professionally for over twenty years, and is nationally recognized in all three areas.

Her first book, *Basic Watercolor Painting*, was published by North Light Publications.

She has been exhibiting her work and teaching professional workshops for painters across the country for the last ten years, and started teaching for the Appalachian Mountain Club in 1991.

This book is a direct result of her work with the AMC.

She lives with her husband (and primary editor) Chris Stokes, three cats, and a dog, in Pembroke, Massachusetts, and maintains a studio in Hanover, Massachusetts.

Recently, she has returned to the classroom in another capacity: she is studying for a Ph.D. degree in art and religious studies and is preparing for a Unitarian-Universalist community-based ministry.

# About the Appalachian Mountain Club

The Appalachian Mountain Club pursues a vigorous conservation agenda while encouraging responsible recreation, based on the philosophy that succcessful, long-term conservation depends upon firsthand experience of the natural environment. Fifty-five thousand members have joined the AMC to pursue their interests in hiking, canoeing, skiing, walking, rock climbing, bicycling, camping, kayaking, and backpacking, and—at the same time—to help safeguard the environment in which these activities are possible.

Since it was founded in 1876, the Club has been at the forefront of the environmental protection movement. By cofounding several of New England's leading environmental organizations, and working in coalition with these and many more groups, the AMC has positively influenced legislation and public opinion.

Volunteers in each chapter lead hundreds of outdoor activities and excursions and offer introductory instruction in backcountry sports. The AMC education department offers members and the public a wide range of workshops, from introductory camping to the intensive Mountain Leadership School taught on the trails of the White Mountains.

The most recent efforts in the AMC conservation program include river protection, Northern Forest Lands policy, Sterling Forest (NY) preservation, and support for the Clean Air Act.

The AMC's research department focuses on the forces affecting the ecosystem, including ozone levels, acid rain and fog, climate change, rare flora and habitat protection, and air quality and visibility.

## AMC Trails

The AMC trails program maintains over 1,400 miles of trail (including 350 miles of the Appalachian Trail) and more than 50 shelters in the Northeast. Through a coordinated effort of volunteers, seasonal crews, and program staff, the AMC contributes more than 10,000 hours of public service work each summer in the area from Washington, D.C. to Maine.

In addition to supporting our work by becoming an AMC member, hikers can donate time as volunteers. The club offers four unique weekly volunteer base camps in New Hampshire, Maine, Massachusetts, and New York. We also sponsor ten-day service projects throughout the United States, Adopt-a-Trail programs, trails day events, trail skills workshops, and chapter and camp volunteer projects.

The AMC has a longstanding connection to Acadia National Park. Working in cooperation with the National

Park Service and Friends of Acadia, the AMC Trails Program provides many opportunities to preserve the park's resources. These include half-day volunteer projects for guests at AMC's Echo Lake Camp, ten-day service projects, weeklong volunteer crews in the fall, and trails day events. For more information on these public service volunteer opportunities, contact the AMC Trails Program, Pinkham Notch Visitor Center, P.O. Box 298, Gorham NH 03581; 603-466-2721.

The club operates eight alpine huts in the White Mountains that provide shelter, bunks and blankets, and hearty meals for hikers. Pinkham Notch Visitor Center, at the foot of Mt. Washington, is base camp to the adventurous and the ideal location for individuals and families new to outdoor recreation. Comfortable bunkrooms, mountain hospitality, and home-cooked, family-style meals make Pinkham Notch Visitor Center a fun and affordable choice for lodging. For reservations, call 603-466-2727.

At the AMC headquarters in Boston and at Pinkham Notch Visitor Center in New Hampshire, the bookstore and information center stock the entire line of AMC publications, as well as other trail and river guides, maps, reference materials, and the latest articles on conservation issues. Guidebooks and other AMC gifts are available by mail order (AMC, P.O. Box 298, Gorham NH 03581), or call toll-free 800-262-4455. Also available from the bookstore or by subscription is *Appalachia,* the country's oldest mountaineering and conservation journal.

# Notes/Sketches